50 GEMS

Buckinghamshire

EDDIE BRAZIL

AMBERLEY

Acknowledgements

Many thanks to all those who helped me during the writing of this book, either through information on photos or advice. Special thanks to all at Amberley, in particular Jenny Stephens for her understanding and patience. Also a great big thank you to my wife, Sue, my island in the stormy sea. Last, but not least, to the county of Buckinghamshire for providing such beauty and history for us all to enjoy.

First published 2018

Amberley Publishing
The Hill, Stroud
Gloucestershire, GL5 4EP

www.amberley-books.com

British Library Cataloguing in Publication Data.
A catalogue record for this book is available from the British Library.

ISBN 978 1 4456 7550 3 (paperback)
ISBN 978 1 4456 7551 0 (ebook)

Origination by Amberley Publishing.

Printed in Great Britain.

Contents

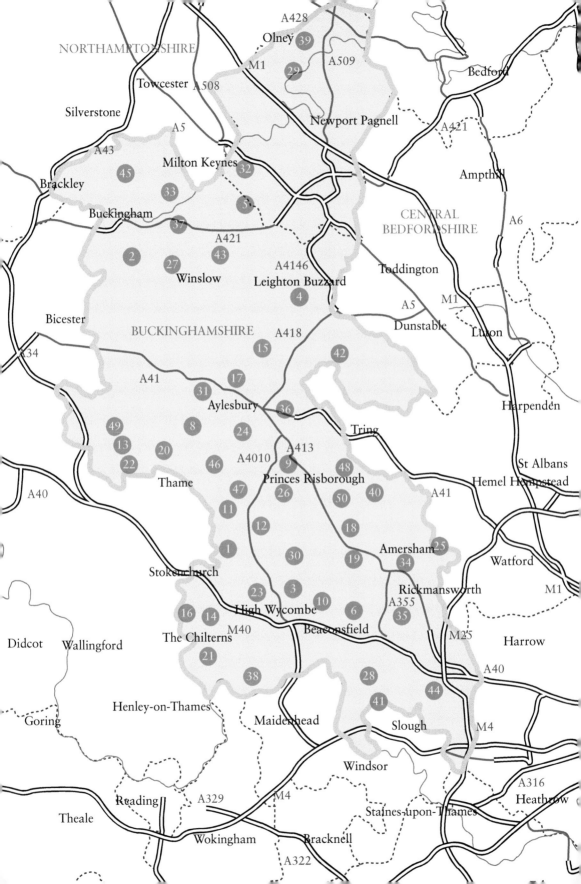

Introduction

Anglophile American writer Bill Bryson once observed that it was impossible to go no more than a mile in Britain without coming across something interesting, fascinating and worthy of losing an hour for. He could well have been describing my own county of Buckinghamshire. The shire is dotted with grand stately homes, quaint and pretty villages, ancient churches, historical towns and intriguing oddities all set within a beautiful, timeless landscape.

The county of Buckinghamshire was created in the late ninth or early eighth century by the Anglo-Saxon King Alfred the Great (reigned 871–99). The territory or shire, which took its name from the 'settlement' or 'ham' of Buccas people, covers an area of 750 square miles and stretches some 52 miles from north to south and around 20 miles west to east. Today its boundaries remain pretty much the same as when it was defined over a thousand years ago.

How does one show off the best of Bucks in fifty gems? For example, within a 15-mile radius of where I am writing there is the site of a Roman villa, three Iron Age hill forts, the Hellfire Caves, the village that gave its name to the American state of Pennsylvania, the former home of Victorian statesman Benjamin Disraeli, the house where Mary Shelly wrote part of her novel *Frankenstein*, a barn that was constructed from timbers taken from the Pilgrim Fathers' ship *Mayflower*, and the stately home where the exiled Bourbon King Louis XVIII accepted the crown of the restored throne of France. All details regarding these and more can be found within this book. It is certainly a difficult choice to make.

Indeed a book of this kind could easily include a further 100 gems – such is the beauty, fascination and history of Buckinghamshire. Yet fifty it has to be, and those contained within are a mixture of the essential inclusions and my own favourites. I apologise if I have omitted any reader's own personal preferences, but hope the fifty locations chosen show Bucks to be a true gem of a county.

Church Gems

1. St Mary's Church, Radnage

At first sight, St Mary's Church, Radnage, would appear to be a church hiding from the rest of the world. Indeed, one might say that it is concealing itself from the rest of the community. For Radnage has an uncommon layout for a village in that it does not have one central point. It comprises a number of separate areas – Town End, Bennet End, City End, Church End – spread out over a wide area (a regular occurrence in Buckinghamshire villages where offshoots of the original centre, either farms or cottage industries, develop as independent hamlets), which nestle together within this remote part of deepest Bucks linked by narrow country lanes. Its name, sometimes spelled Radeneach or Rodenache in old documents, means 'red oak' in Old English.

Radnage is not mentioned in the Domesday Book and it appears from a thirteenth-century document to have been a royal demesne, or crown land. Throughout its history it has been associated with Henry I, who granted it to the Abbey of Fontevraud in France, King John, who granted it to the Knights Templars, and Charles II, who gave it to one of his mistresses.

However, if the village has no visible centre, its ancient heart is undoubtedly St Mary's Church. As one approaches from the south the church reveals itself like a lone distant ship in sail riding the woods and fields of the Chiltern Hills. Further on, and descending through the winding lanes, the church is lost from view within the folds, and one wonders where the building has gone to. Soon, as the lane begins to climb, a faded sign by a side road points the way. Here, up a short drive, is St Mary's Church and its only companion, an eighteenth-century rectory.

Pushing open the graveyard gate we immediately find ourselves in one of the most beautifully situated churches in Buckinghamshire. The views stretch back across the valley to a vista of little fields and beech woods, while above, kites swoop and soar as their shrill whistle cry calls out.

Sitting in Radnage churchyard on a warm summer's afternoon, as my wife and I have often done with a picnic and bottle of wine, it feels as if the rest of the world is far away, and that St Mary's has been forgotten. Indeed that may have well been the case for the church is an architectural gem untouched by later Victorian restoration.

Built by the Knights Templar in the late twelfth or early thirteenth century, it consists of a nave, central tower and chancel with three original lancet windows.

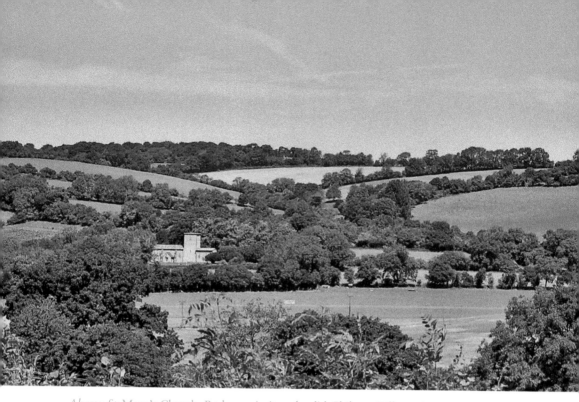

Above: St Mary's Church, Radnage, in its splendid Chiltern Hills setting.

Below: The entrance to St Mary's churchyard, one of the most beautifully sited in Buckinghamshire.

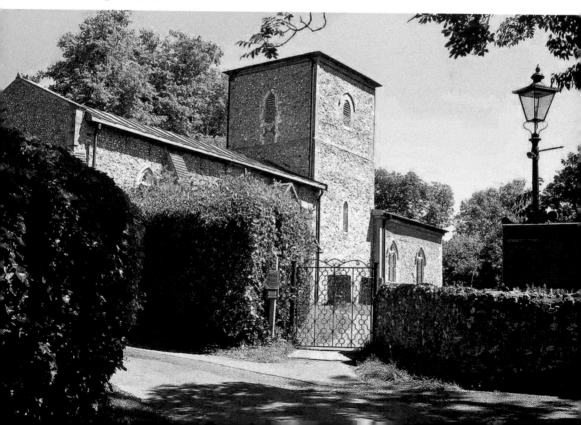

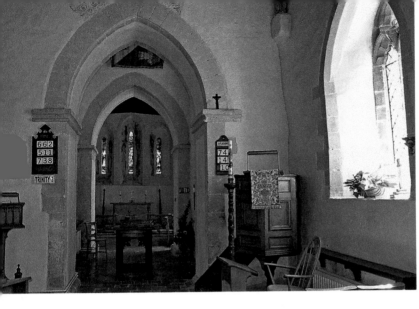

The interior is plain and chalky white, and is pervaded by an odour of ancient mustiness. The walls are adorned with remnants of thirteenth-century painted figures together with texts from the bible, which were only rediscovered in the 1960s.

The pulpit is late seventeenth century, and the simple font may well hint at St Mary's history stretching back before its thirteenth-century origins, for it is thought to be late Saxon. Incredibly, it was thought to be lost until being dug up in a neighbouring field.

For those of you who sometimes require a rest from the hustle and bustle of the modern world, a visit to Radnage is recommended. A peaceful and tranquil summer's afternoon, in beautiful surroundings, together with England's ancient past, is a perfect combination – and don't forget the wine.

2. All Saints Church, Hillesden

Considered to be the finest late Gothic Perpendicular church in Buckinghamshire, All Saints, Hillesden, stands in an isolated hamlet at the top of a gentle hill in the remote north of the county. It owes its splendour to the monks of the twelfth-century Notley Abbey, near Long Crendon in south Bucks, who, in 1493, rebuilt it following accusations that they had let it become ruinous. In 1538 their abbey was dissolved by Henry VIII, and nine years later, in 1547, Hillesden church and the manor were acquired by the Denton family. In one fell swoop the Dentons had obtained a building recently completed and one they swiftly adjusted to the celebration of their family rather than the church.

The interior is airy and spacious with light flooding in through the grand perp windows and clerestory, bathing the nave, aisles and chancel in a soft honey-coloured glow. There are small transepts and a north chapel as long as the chancel. It is here that the grand monuments to two of the Dentons stand: Thomas Denton (d. 1560) and his wife, and Alexander Denton (d. 1574).

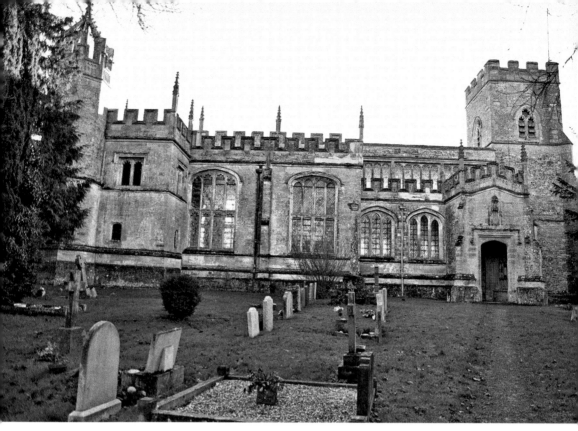

Above: Exterior of All Saints, Hillesden, the finest Perpendicular church in Bucks.

Below: The bright, lofty interior of Hillesden church.

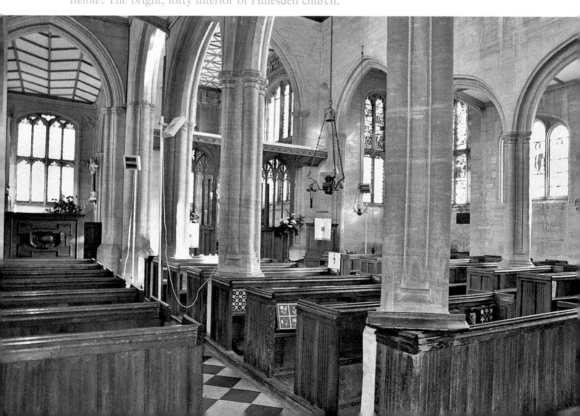

Throughout the church further memorials to the Denton family can be found, and yet, are made all the more poignant when one considers the fate that would befall the Dentons in the bloody conflict between Charles I and Parliament during the English Civil War.

Hillesden house, which stood just to the east of the church, was the home of Sir Alexander Denton. He was Member of Parliament for Buckingham and was also a Royalist. In March 1644 he fortified his house with a garrison of 260 men in support of the Royalist cause. At the time the house was occupied by members of the Denton family and also some of the Verney family from nearby Claydon.

Such a position could not be tolerated by the Roundheads. A force of 2,000 men under the command of Oliver Cromwell laid siege to the house The Parliamentarians quickly overcame the defenders, but some Royalists retreated to the church and barricaded the doors. These were soon broken in with musket fire, the scars of which can still be seen today. Those who tried to make a last stand in All Saints were told they would be given quarter and allowed to leave unharmed, yet on exiting the church forty of them were taken in to the churchyard and shot. Before the Roundheads departed they entered the church and smashed the stain-glass windows and disfigured the Denton monuments.

The members of the Denton and Verney families were allowed to leave Hillesden house without harm, yet Sir Alexander Denton and his offices were taken prisoner and marched to Padbury, where they were locked in the church for the night before continuing their route to Aylesbury.

Sir Alexander Denton would never again see his beloved home. To prevent it falling into Royalist hands the house was burnt to the ground, and on New Year's Day 1645 the lord of Hillesden died in the tower of London.

The south door of Hillesden church still shows the musket ball damage from the siege of 1644.

3. St Michael's Church, Hughenden

Hughenden is first mentioned in the Domesday Book of 1086 and was called 'Huchendene', or 'Hugh's Valley' in modern English. However, the name could also refer to the Anglo-Saxon thane Huhha, rather than the Norman French Hugh. At the time of the great survey of England, the village was in the extensive estates of Odo, Bishop of Bayeux, who was the half-brother of William the Conqueror.

Today the village of Hughenden has long gone, and the area has become a suburb of High Wycombe, but not an unattractive one. As one heads north out of the town the houses and shops abruptly cease, and the traveller is immediately surrounded by a hilly landscaped park on one side and the gentle rising slopes of the Chilterns on the other. This is Hughenden Valley, and in 1848 eminent Victorian Benjamin Disraeli, who would later become Prime Minister and Queen Victoria's favourite, made it his home when he bought the estate including Hughenden manor (*see* Stately Homes).

Disraeli decided not only to remodel his house but also to rebuild the twelfth-century Church of St Michael, the only remaining part of ancient Hughenden. The building stands at the side of the drive leading up to the manor, and is known locally as the church in the park. The views from the churchyard give an attractive vista over the park and surrounding Chilterns.

Hughenden church in its Chilterns setting.

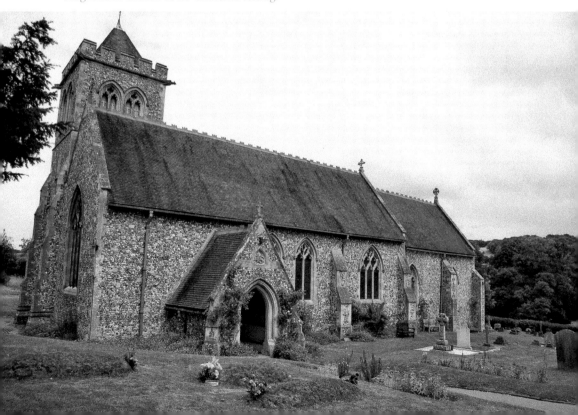

Like many Victorians of the time, Disraeli wanted to return the appearance of the church to its medieval origins. Indeed from 1840 the love of all things medieval became known as the Gothic Revival.

When Disraeli arrived at Hughenden the Gothic craze had taken hold, and between 1874 and 1890 he set about rebuilding St Michael's. All that was retained from the medieval church was the north chapel, the sixteenth-century arcading between it and the chancel, and a late twelfth-century font.

The interior – in particular the chancel – is a perfect example of how the Victorians imagined the medieval period of church decoration. It is a romanticised version of fourteenth-century Gothic architecture. It is separated from the nave by a low, open wrought-iron screen. The floor is covered with ceramic tiles and the walls decorated with wall paintings depicting the Nativity, the four evangelists and the Prophets. The east window is set with nineteenth-century stained glass.

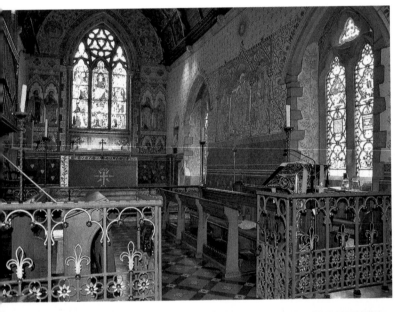

The lavish Victorian restored chancel of Hughenden church.

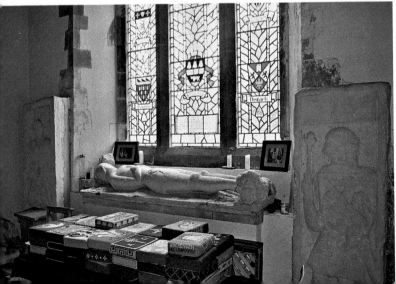

The north chapel at Hughenden showing two fake tombs, an attempt by a one-time lord of the manor to prove ancestry from the de Montfort family.

On the north wall is the white marble memorial to Disraeli, prime minister in 1868, and 1874–80, who died in 1881, which was erected by Queen Victoria.

For those keen on St Michael's medieval past the north chapel is of curious interest. In a niche behind the chancel north wall is a rather macabre early sixteenth-century stone cadaver, which seems as if it has stepped out of the pages of an M. R. James ghost story. A somewhat eerie spectacle to come across as I discovered when I was alone in the church one cold dark winter afternoon.

Further mysteries are to find in the north chapel. Within are effigies of four knights one of which is genuine and dates from the fourteenth century, while the other three, which were seemingly executed in the fifteenth century, are fakes. The workmanship would appear to be obviously crude, and it is remarkable how they could have fooled anyone with their inferior carving.

They were fashioned in the sixteenth century to give a spurious connection with a local family, the Wellesbournes, and to Simon de Montfort, the father of the English parliament.

4. All Saints Church, Wing

One other church that escaped almost certain calamity when plans for London's third airport were proposed in the 1970s was All Saints in the village of Wing, which is only 4 miles from Stewkley. Within a few days of Wing being identified as a possible site a local airport resistance association was formed to oppose the scheme. Happily they succeeded, the plans were dropped and Wing, the surrounding villages and the Vale of Aylesbury were spared the nightmare of destruction and the constant roar of aircraft.

All Saints is one of the most important Anglo-Saxon churches still standing not only in Buckinghamshire, but also England. It is thought to date from the late tenth century, and is rare because it retains its crypt, above which stands a grand seven-sided apsidal east end, a Saxon nave, aisles and west wall.

The Saxon origins of the church and village reach far back. An ancient track, part of the historic Icknield Way linking Oxford with Cambridge, once passed through Wing. The name of the village occurs in Old English, c. 966–975 as 'Weowungum', possibly meaning 'the sons or family of Wiwa'. Alternatively it is thought the name means 'the dwellers or disciples of the heathen temple'. This heathen temple might refer to a Roman structure that had stood on the site beforehand. It is also possible that the site of All Saints has been used as a place of worship long before the legions arrived on our shores.

The interior of the church is one of lofty proporations, whitewashed and scrubbed clean. The Saxon arches from the nave to the aisles are simple openings cut through thick walls. The apse is higher than the nave and is entered through one of the largest arches of its period in England.

Curiously the Normans seem to have left the church alone, for the later additions to the fabric came in the thirteenth century with the construction of a south aisle, and the tower, clerestory and apse windows were added in the fifteenth century.

Inside the church one will also find many impressive and important monuments to the Dormer family. They came to nearby Ascot Hall in the 1520s, and their memorials dominate the church. The most impressive is the one commemorating Sir Robert Dormer (d. 1552). An architectural composition of English and Renaissance details, it is considered to be the best example of its style and date in England.

Other grand Dormer monuments face each other across the apse. William Dormer (d. 1575) and his wife with kneeling figures were completed in 1590. A further memorial is to Sir Robert, 1st Lord Dormer (d. 1617), and his wife.

Although Wing is today a somewhat busy village with perhaps a little too much traffic, its church lies tucked away along Church Street and is surrounded by pleasant terraced cottages. All Saints is undoubtedly an architectural and historical must see for the church crawler eager to experience the work of our Anglo-Saxon ancestors.

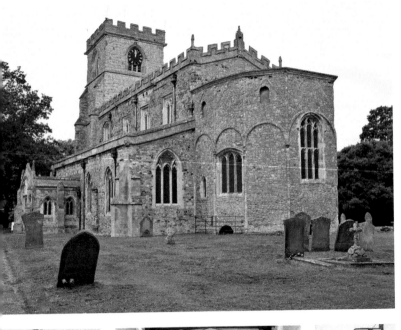

The exterior of Wing church showing the Saxon apsidal east end.

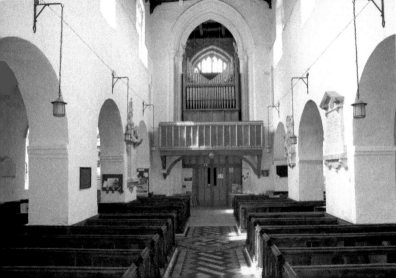

The solid whitewashed interior of All Saints.

5. St Mary's Church, Willen

St Mary's Church, Willen, is indeed an oddity, but one worth the effort in seeking out. Like Stewkley church, it would seem to be a building totally out of sync with its surroundings, for here in the brave new world of Milton Keynes new town stands a seventeenth-century gem of a church, which one might feel would be more at home in the city of London.

St Mary's was built in 1680 on the site of a medieval chapel or church for the headmaster of Westminster school, Richard Busby, by Robert Hooke, a friend of Sir Christopher Wren and designer of the Monument to the Great Fire of London. Hooke had been a pupil of Busby at Westminster. He regarded himself more as a scientist than an architect, and made the astonishing claim that it was he who had discovered the laws of gravity, not Sir Isaac Newton.

Whatever the truth of the claim, his church is a charming building of square west tower and tall, narrow nave standing on a small hill. The original chancel was demolished in 1861 and an apsidal Victorian one replaced it. The church is enclosed in a graveyard with old brick walls and iron gates, and is best approached from the west along an avenue of lime trees. The lowering western sun glows against the orange bricks of the tower as it looks out over fields and the vast expanse of the newly created Willen Lake.

What would Busby and Hooke make of it all if they could return? A new town? An artificial lake? When Sir Nicholas Pevsner visited the church in 1960 for its inclusion in his *Buildings of England, Buckinghamshire*, the location must have looked little changed from when the church was completed in the seventeenth century – a small medieval village by the River Ouzel with a church, vicarage, two large farms and a scattering of cottages.

In 1967, Willen was swallowed by the proposed new town of Milton Keynes. Despite the needs of the expanding city, the area around the church retains a

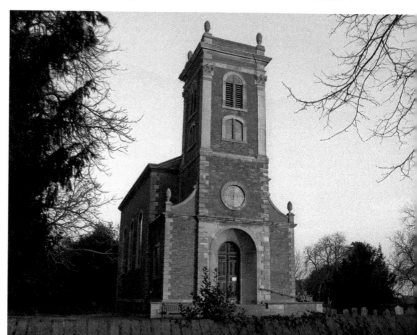

Late afternoon sunshine glows against the red brick of St Mary's, Willen.

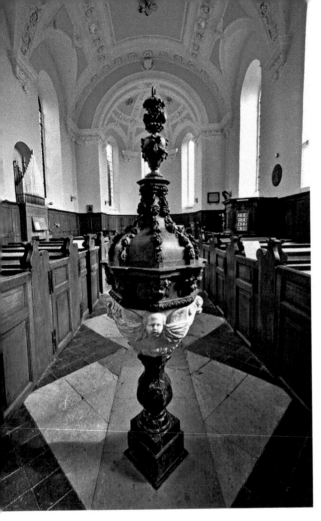

somewhat peaceful aspect. Certainly Busby and Hooke would still recognise the
interior of St Mary's. The church is entered by the west door, which is set into stone-
faced recess in the tower similar in design to Wren's church, St Mary-le-Bow in the
city. Within is a delightfully unrestored interior. Pews, stall fronts, the west door,
wall panelling, an organ case and the font are all original, as is the pink and white,
exquisitely decorated, barrel-vaulted ceiling.

6. Quaker Meeting House, Jordans

The meeting house at Jordans has been described as the 'Westminster Abbey' of
the Society of Friends, or Quakers, a title bestowed upon the societies' firebrand
preachers who would literally shake and quake with religious fervour as they recited
the scriptures. Although it is indeed the most important Quaker building in the world,
and also the last resting place of one of its most illustrious friends, William Penn, the

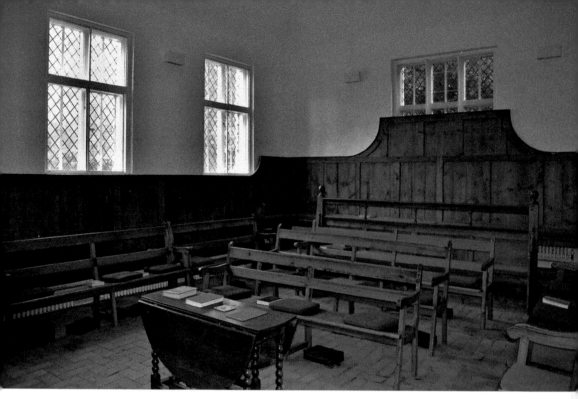

The equally plain and austere interior.

comparison with Westminster Abbey is as contrary as one could imagine. For here the visitor will find a plain simple brick building with a hipped roof covering a one-storey chamber. The interior is an unadorned wood-panelled room with plain benches, a brick floor and shuttered windows looked down upon by a creaking gallery – a Spartan place of worship reflecting the Quakers egalitarianism and rejection of pomp and ceremony.

It was built in 1688 following James II's Declaration of Indulgence in 1687, and subsequent Toleration Act of 1689, which offered all Dissenters freedom of worship. Prior to this Quakers had to meet in secret with the threat of prosecution and imprisonment for their beliefs. South Buckinghamshire had long had a tradition of religious dissent. The Quakers had been gathering in the Chilterns for many years before the building of the meeting house. William Russell, a prominent Quaker, was a proprietor of the adjacent Jordans farm in which the society came together in secret. The farm still stands and retains relics and reminders of those Pilgrim Fathers who escaped England for the New World so they could worship in freedom. Part of the farms timbers, and possibly part of a cabin door, are said to have been salvaged from the *Mayflower*.

William Penn was a Buckinghamshire man. He claimed the nearby village of Penn as his ancestral home. He founded the city of Philadelphia and the settlement of Pennsylvania is named after him. He, along with his wife, was a frequent attender at the meeting house. In 1718 he was buried in the grounds along with other prominent friends.

Curiously, the state of Pennsylvania sought to have his remains returned to America and reburied in the state capital, Harrisburg, but the friends replied that such a removal and reburial accompanied by pomp, circumstance and a military honours parade would have been repugnant to Penn's character and sentiments. Nonetheless, on one occasion two men had to be stopped from trying to exhume them.

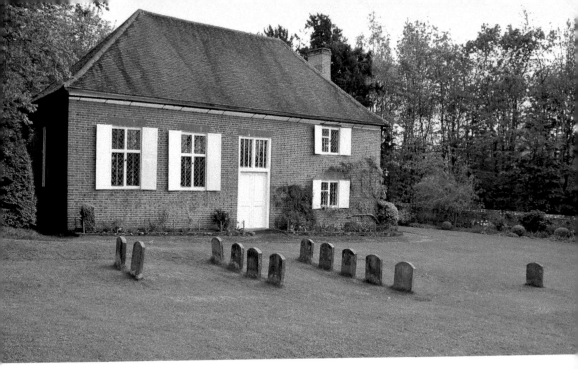

The simple, plain design of Jordans meeting house.

7. Stewkley Church

Stewkley church is an incongruous architectural gem. Seemingly out of place in a large, suburbanised village, it has managed to survive as the modern world has grown around it. Built between 1150 and 1180, it is a near perfect example of Norman architecture with minimal later Gothic additions. The west front on the main road displays exuberant zigzag carving over a triple-arched west door. The zigzag design is continued above the door within a single typical Romanesque window.

To enter the church is to partly step back over 800 years, for it is mostly unrestored with the Victorians restraining themselves to just a liturgical reordering of layout.

In the twelfth century the church would have been crowded with screen, icons, paintings, the soft glow of candles, earth floors, the grey wafts of incense and the constant coming and going of villagers in need of spiritual fulfilment. Today the place is scrubbed and orderly.

The building is divided into three cells, a nave, a tower and a chancel. Yet one cannot be unimpressed by the beauty of the carving on the tower and chancel arches. Although typically massive in the Romanesque style, the flow and grandeur of the design retains a solid gracefulness.

Stewkley church is undoubtedly a survivor and an architectural and historical delight. Stepping back outside the building into the rush and flow of the twenty-first century can be a little jarring. As we take one last look back, perhaps it is sobering to remind ourselves that the people who designed and built the church were Normans who would have spoken French. Those Anglo-Saxon peasants who entered to perform their daily devotions spoke an English unintelligible to us today.

If they could return to Stewkley today they would no doubt still recognise the church they once worshiped in. Perhaps more puzzling to them would be the idea that it was once proposed to move the church from its current position. In the 1970s the church narrowly escaped disaster when it was proposed to build London's third airport at nearby Cublington. The authorities, generously, offered to move the building, although to whereabouts wasn't made clear. Happily, sanity prevailed. The third airport is yet to find a home, and Stewkleys Norman glory remains to please us all.

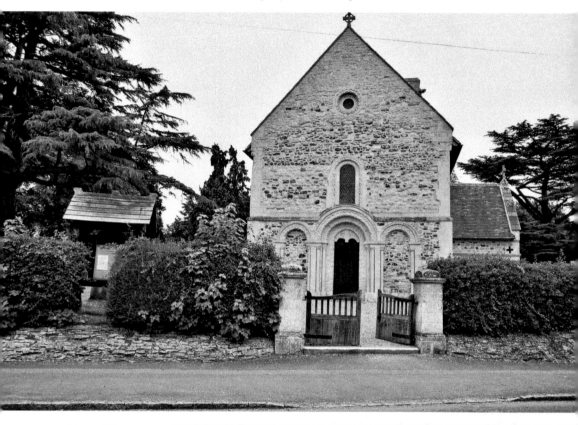

Above: The Norman west front of Stewkley church.

Right: The massive and majestic interior.

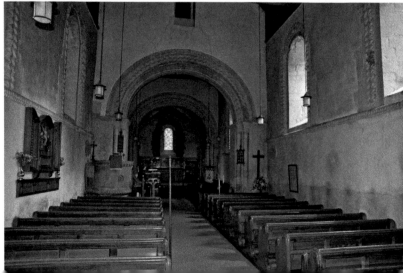

8. St Nicholas' Church, Nether Winchendon

The parish church of St Nicholas, Nether, or Lower Winchendon, like the village it provides with spiritual guidance, seems to be a world away from the hurly burley of modern-day Buckinghamshire. It sits within a valley of soft rolling hills and the water meadows of the River Thame beneath its name sake up on the Chiltern ridge, Upper Winchendon.

There has been a church at Lower Winchendon since as far back as the eleventh century, when the manor belonged to Queen Edyth, wife of Edward the Confessor. The building we see today, however, is early thirteenth century, but there are ancient stones at the base of the tower indicating that a Saxon church once stood on the site. Apart from its location, the chief attraction of St Nicholas' is its interior, for it has remained remarkably unchanged since the eighteenth century.

It is a fine example of how village churches looked before the Victorian restorers got to work. Within there are box pews, a seventeenth-century Jacobean three decker pulpit, the West Gallery, the Hanoverian royal arms of George IV, an organ and chandeliers. There is also fifteenth-century English and sixteenth-century Flemish stained-glass windows. They were removed from the church during the Civil War to avoid destruction and hidden in Nether Winchendon House, only returning to the church in 1958. All is appropriately lit by lamps and candles. It does indeed feel that one has stepped back to another time.

St Nicholas' at Nether Winchendon, the archetypal English village church.

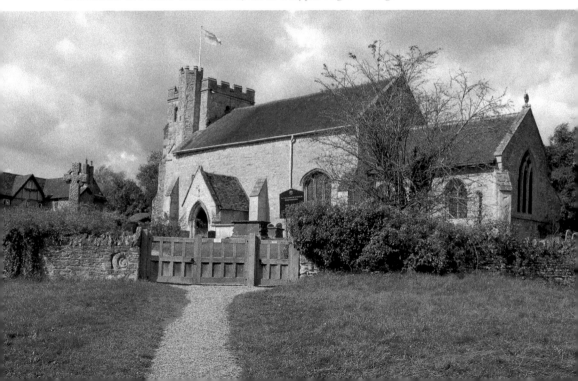

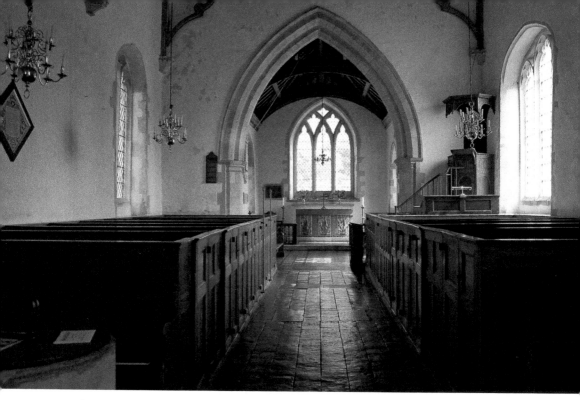

The untouched interior complete with box pews, three-deck pulpit and candelabras.

This feeling is continued outside in the churchyard. As the visitor relaxes on the bench in the warm sunshine, the village sits dreamily in the afternoon. Here, one will not find a pub, or post office or local shop. Passersby are rare, and the solitary cottages straggle along the lane passed the sensibly retained red telephone box, all sited within beautiful Chiltern scenery. One almost expects Miss Marple to come down the hill on her bicycle en route to solve another murder. Nether Winchendon and its delightful church are a reminder that there are still places in England where one can escape the madness of the world.

9. St Nicholas' and All Saints, Great and Little Kimble

The busy A4010 between Princes Risborough and Aylesbury might seem an unlikely place to discover gems of Buckinghamshire. The villages of Great and Little Kimble, which lay along its route and sit virtually within shaking-hands distance of each other, seem to have been swamped by the speeding traffic. They are in a location one would probably think is not worthy of stopping in, content to rush through on the way to some where else. However, they would be wrong, for here the history buff, if they look closely, can find fascinating remnants and reminders of Britain's turbulent past.

Great Kimble church, the site of the spark that ignited the English Civil War.

The name Kimble is thought to be Anglo-Saxon, the name Cyne Bell meaning royal hill. Other sources suggest that the name may derive from Cunobelinus, King of the Catuvellauni, a British Celtic tribe who ruled this part of southern Britain from around 4 BC to AD 41 when the Roman legions invaded.

The Anglo-Saxons description of royal hill may well refer to the fact that three quarters of a mile south-east of Great Kimble church, and on the summit of Pulpit Hill, there are the remains of an Iron Age or Bronze Age hill fort dating from the 1st millennium BC. Its true purpose is unknown, but it could well have served as a Catuvellauni royal stronghold.

Further reminders of Britain's ancient past are to be found on the west side of Great Kimble church. Adjoining the churchyard and fronting Church Lane is a funeral mound or barrow. It is tempting to link the burial mound with a long-lost Catuvellaunian king, but it is thought to date from the Roman period, possibly containing a one-time resident of a Roman villa that stood on the east side of Little Kimble church.

Evidence of the Norman Conquest of England can be discovered to the east of Little Kimble church. Here the mounds and banks are all that remain of a motte-and-bailey castle erected soon after 1066. It was constructed by the new Norman landowner who was aware that he was surrounded by dispossessed and hostile Englishmen.

Although from the outside appearing seemingly modest and uninteresting, and having the look of a Victorian cemetery chapel, All Saints Church in Little Kimble dates from around 1250 with windows in the north wall of the chancel dating from

the early fourteenth century. The north and south porches, along with the doors and windows of the nave, also date from this period. The chancel contains thirteenth-century medieval tiles possibly taken from the ruins of Chertsey Abbey in Surrey. However, the churches chief glory is its wall paintings.

Dating from the early fourteenth century they are the most extensive in Buckinghamshire. They include St Francis preaching to the birds and a large figure of St George, but not all can be identified. There seems to have been a doom painting on the west wall, depicting a devil pushing two women into the mouth of Hell. On the north wall facing the south door St Christopher is depicted.

All Saints is a perfect example of never judging a church by its outward appearance. The same must be said of St Nicholas', just a stone's throw away up the road. The building was constructed in the twelfth century and added to during the thirteenth and fourteenth centuries. However, like most medieval churches in England it was completely restored in 1876–81.

St Nicholas' Church's fame rests upon the events that took place there in January 1635. Sir John Hampden was a local landowner and Member of Parliament for Aylesbury. In 1635 Charles I needed money to improve the navy. A levy was traditionally collected from coastal ports and towns, and the king tried to impose the tax on all the counties in England. This move was unconstitutional in the eyes of Hampden and his supporters. In January 1635 Hampden and other Buckinghamshire landowners met at St Nicholas' Church and all agreed to refuse to pay the tax. It was a decision that would ultimately lead to civil war, the beheading of the monarch and, for a period, turn England into a republic. Britain and the monarchy would never be the same again. These were momentous events in the history of the nation, the spark of which was ignited in this obscure Buckinghamshire church.

Medieval wall paintings at Little Kimble church.

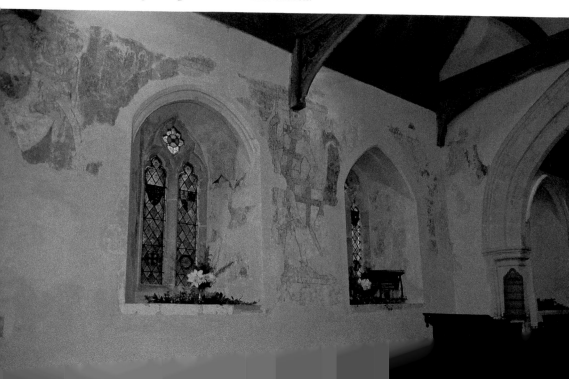

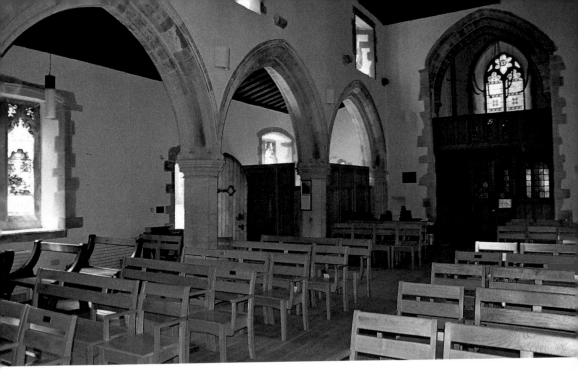

The restored interior of Great Kimble church.

10. Penn Church

As mentioned in the introduction to this book, American author and Anglophile Bill Bryson once observed that it was impossible to walk a mile in Britain without coming across some fascinating historical fact, or interesting curiosity. He was, of course, quite right.

The Church of Holy Trinity in the village of Penn near Beaconsfield in the south of the county is a good example of an ordinary Buckinghamshire location with some extraordinary connections. Sir William Penn, founder of the city of Philadelphia in the USA, and after whom the state of Pennsylvania takes its name, claimed Penn as his ancestral home. His grandsons lie within the church crypt, and Sir William, his wife and family lie in nearby Jordans churchyard.

The church is also the last resting place of David Blakeley. He was murdered by Ruth Ellis, the last woman to be hanged in Britain. Her grave is in nearby Amersham churchyard. Holy Trinity also contains the graves of the parents of the spy Donald MacLean. He, along with Guy Burgess and Kim Philby, betrayed Britain's military secrets to the Soviet Union just after the Second World War. After they this discovery all three defected to Russia. When MacLean died in 1983, his will requested that his ashes be returned to England and scattered on his parents' grave.

Other former residents of Penn include the actor Stanley Holloway, poet Walter de la Mare, libretis W. S. Gilbert, and Louisa Garret Anderson, the daughter of the first woman in Britain to qualify as a doctor.

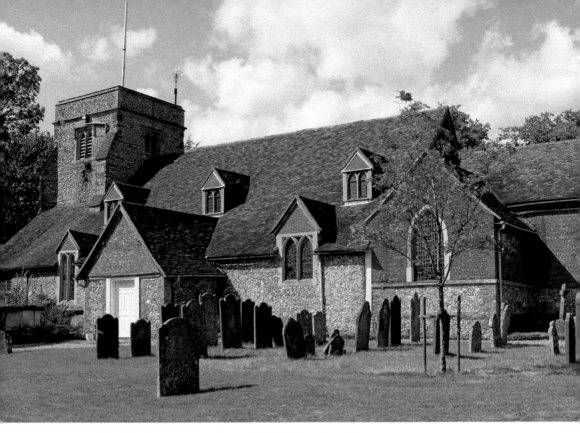

Penn church where the grandsons of Sir William Penn lie.

The church contains a good collection of brasses, hatchments, consecrations crosses and modern stained glass, yet its chief treasure is a fifteenth-century doom painting above the chancel arch. It is considered one of the finest in England, and it was miraculously saved from destruction when it was almost consumed by fire in 1938 when it was burned as scrap before an eagle-eyed clergyman recognised it just in time.

Village Gems

11. Bledlow

Bledlow derives its name from the last resting place of Bledda, an eighth-century Anglo-Saxon chieftain. His burial mound, or 'hlaw' in old English, is said to be located on the wooded slopes that rise up south-west of the village. However, the name may well mean 'Bloody Hill', referring to an undated battle between the Saxons and the Danes.

Bledlow is split into two sections. The cottages and houses that line the B4009 between Princes Risborough and Thame are plagued by the passing traffic. Yet, half a mile south off the main road one soon enters the peace and quiet of a rural community.

Bledlow village church bathes in late winter sunshine.

The village consists of a main street lined with Georgian houses and cottages, a medieval church, a sixteenth-century pub, the grand Bledlow manor, a seventeenth-century house, home to the Carrington family (Peter Carrington, the 6th Baron Carrington, who inherited the house in 1938 and set about restoring the gardens, which are open to the public, served as a minister in Margaret Thatcher's cabinet during the early 1980s), plus the extraordinary Lyde Garden, which is an exotic water garden planted in a deep ravine east of the church. The churchyard overlooks the gully where water from eight springs emerges. The garden has been beautifully landscaped with walkways, bridges and a small colonnade at the southern end creating a very peaceful atmosphere. The name 'Lyde' probably derives from the Old English 'hlud' ('loud'), meaning 'roaring stream', suggesting a much more forceful flow of water in earlier times.

Adjacent to the garden the churchgoer will find a largely unaltered building dating from the twelfth and thirteenth centuries, with a twelfth-century Aylesbury font and fine thirteenth-century carvings on the piers.

If one needs refreshment there is no better place than the Lions public house at the west end of the village. It possibly dates back to 1578 and is often used as a filming

The enchanting Lyde Garden at Bledlow.

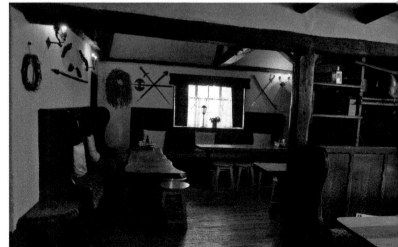

The interior of the Lions public house. It was used on many occasions as a setting for the TV show *Midsomer Murders*.

location for the TV crime series *Midsomer Murders*. Low beams and careworn flooring give the pub a timeless feeling.

Sometimes synchronicity can make a visit to Bledlow that much more rewarding if one is lucky. One warm cloudless summer's afternoon my wife and I visited the pub for a well-deserved pint. As we sat outside in the sunshine two riders clopped past on their way to the bridal path, which leads up to the Icknield Way. Down on the village green a cricket match was in full swing. To complete the perfect picture a steam train from the Chinnor and Princes Risborough preserved railway chuffed and hooted its way along the line in the valley. It could have been a vista from seventy years ago. My wife and I looked at each other and smiled. It was a moment of blissful serendipity.

12. Bradenham

To come across Bradenham village on a cloudless summer's afternoon, with a cricket match in full swing on the green, the sound of leather on willow accompanied by a ripple of gentle applause, and the parish church tower chiming the hours, is perhaps, for many, a perfect, idyllic vision of England.

It is a curiously shaped village with a long triangular green, a handful of eighteenth-century cottages all lining one side of the main road, and the dominating vista of the parish church and red-brick manor house sitting below the wooded Chiltern ridge within the Saunderton valley midway between High Wycombe and Princes Risborough.

Bradenham dates to at least the Saxon period, and is mentioned in the Domesday Book. The parish church of St Botolph was built around 1100, and although much restored in 1863, it retains its Norman south door, which is thought to be the oldest in Buckinghamshire.

Bradenham church and manor from the village green.

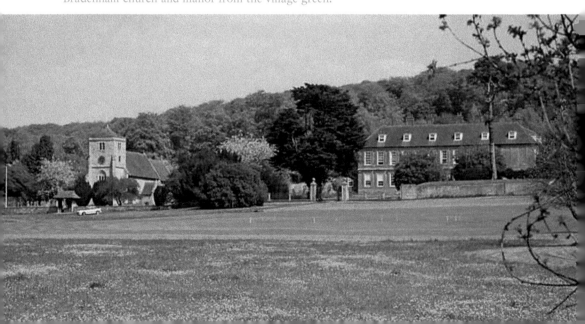

Bradenham Manor, once home to Benjamin Disraeli's father.

The first manor house was built by William, Lord Windsor, between 1543 and 1558. William's son, Edward, entertained Elizabeth I at Bradenham in 1566, but the house we see today is largely a product of the mid-seventeenth century. It was once the home of Isaac Disraeli, father of British prime minister Benjamin Disraeli, who lived there for part of his early life. Isaac died in 1848 and is buried in the church.

The northern edge of the village green, beside the road, is lined with lumps of Palaeogene puddingstone (which are 23 million years old). Pieces of this naturally occurring rock are found dispersed throughout the locality. An Ice Age sarsen stone, unearthed nearby, was erected by Bradenham Parish Council on the green to commemorate the dawn of the third millennium.

North-east of the church, in a small meadow beside Bradenham Woods Lane and shaded by trees, is an unusual feature of the landscape. On first inspection it would appear that Bradenham is the site of some ancient ritual stone circle. Dotted across the meadow – like a miniature Stonehenge or Avebury Circle – are a series of stones and boulders of various shapes and sizes. The stone circle, however, is not the work of some long-lost civilization, but a peculiar feat of nature that was produced by a deposit left behind from the days of the great Ice Age.

13. Brill

Brill is a wonderfully sited village on top of a hill with far-reaching views over Buckinghamshire and distant Oxfordshire. Around its village green and square are dotted attractive period cottages and sympathetically designed modern dwellings that do not jar or detract from the village's ambience.

It is a place steeped in history. The name 'Brill' is a combination of Brythonic, or British, and Anglo-Saxon words for 'hill' (the British 'Bre' and Anglo-Saxon, 'hlaw'),

suggesting that Iron Age Britons occupied the site before the coming of the English. It is indeed possible that the Celtic tribes and Angles live here in peace.

The Saxon King Edward the Confessor is believed to have had a palace here. Subsequent monarchs such as Henry II, John, Henry II and Stephen all held court at Brill Palace. William the Conquer is thought to have hunted in Brill, and Henry III signed a charter in the village with Thomas à Becket as a witness. Henry VIII also hunted in the area. During the English Civil War the buildings palace buildings still remained and were fortified by the Royalists, who had occupied it as an outpost of Oxford. It was unsuccessfully besieged on three occasions by the Roundheads. It only fell to Parliament in 1643 when Sir John Hampden stormed the village.

The Church of All Saints was largely restored in 1888, and sadly has few things of note. However, a bank and ditch near the church are thought to be the last remaining evidence of Edward the Confessor's palace. The site of the palace also shows signs of the fortifications of the defensive earthworks built by the Royalists during the siege.

Brill is also known for its windmill dating from 1685. The windmill is one of the earliest and best-preserved examples of a post mill in Britain. The curious contours on Brill common are the result of hand digging clay, the raw material for two important Brill industries: the production of pottery and brick making.

Pottery was produced in Brill from Roman times to within living memory. Following the demise of the industry the hills and hollows left by centuries of clay digging were used by the villagers as repositories for household rubbish and the contents of privies.

For those lovers of the epic fantasy *Lord of the Rings*, Brill was the inspiration for the Middle Earth town Bree. Its author, J. R. R. Tolkien, lived in the village for a short while.

The seventeenth-century windmill and the remains of clay-digging pits at Brill.

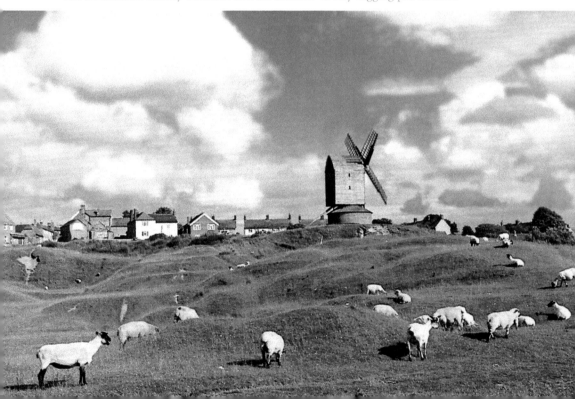

14. Fingest

Fingest is another beautiful Chilterns location that fulfils all the requirements one looks for in the quintessential English village. It can be found just a few miles from Turville (*see* Turville) and is surrounded by stunning Buckinghamshire scenery. The village name comes from the Old English 'Thinghurst', meaning 'wooded hill where assemblies are made'. In the sixteenth century the name is recorded as 'Thingest' and then 'Fingest'.

The manor of Fingest belonged to the St Albans Abbey in Hertfordshire. In 1163 it was given to the bishops of Lincoln, and the north side of the church is thought to be the site of their palace. The Church of St Bartholomew is a curiosity in that its massive tower dominates the tiny body of the church, and is the one landmark one immediately takes in when you enter the village.

The huge Norman tower is 20 metres high and has walls over a metre thick. It was built in the early twelfth century, and is topped by unusual twin gables – it is believed that only one other similar church tower exists in England. The nave of the church is joined to the tower by a twelfth-century arch, suggesting that the tower was at one time the original nave. Although the church was restored in 1866, it still retains its thirteenth- and fifteenth-century lancet windows. The font is from the fourteenth century and there are royal arms of Queen Anne.

Fingest village nestles in its Chilterns valley.

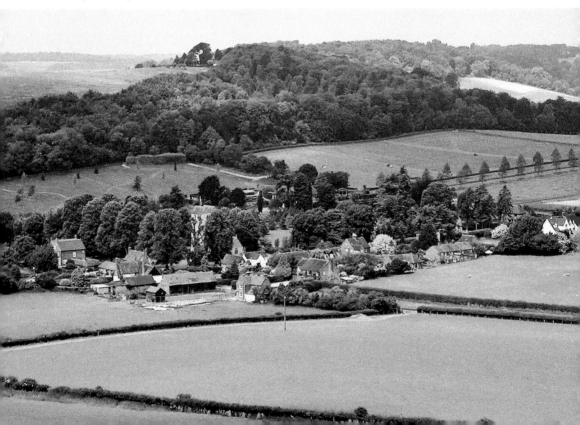

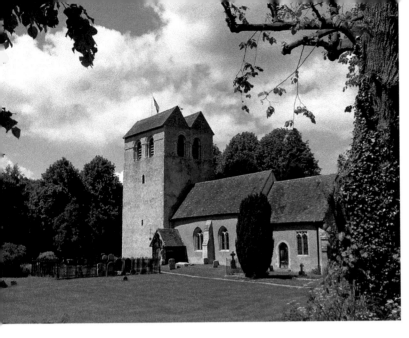

Fingest church with its distinctive saddleback west tower.

The beauty of Fingest lies in its combined charms. There is its lovely, peaceful location, the perfect centre of St Bartholomew's Church and the eighteenth-century Chequers Inn, its period cottages and a sensibly retained red telephone box. It is no wonder that the village has been used as a location in the popular *Midsummer Murders* TV crime series. Yet for all its Englishness, in 2013 Fingest was transformed into a village in Normandy for the Hollywood movie *The Monuments Men*. No doubt the Frenchmen who built the church tower would have approved.

15. Whitchurch

Whitchurch is an attractive village in the Vale of Aylesbury between the towns of Aylesbury and Buckingham. It was the childhood home of Joyce Anstruther (pen name Jan Struther), author of *Mrs Miniver*, a novel based on Anstruthers experiences in wartime Whitchurch. It was made in to an Oscar-winning Hollywood movie, and is believed to have contributed to persuading America to join the war.

The village contains many attractive old houses, and despite the rush of traffic on the A413, it still retains an air of peaceful charm. One of the finest buildings is the fifteenth-century priory to the south-west of the church. There are other notable houses dating from the sixteenth, seventeenth and eighteenth centuries.

The parish church of St John the Evangelist dates from the thirteenth century, but has additions from later years. The south aisle was added in the late thirteenth century, with the north aisle being added later. The south door is from the early fourteenth century, as are the sedilia and piscina in the chancel. The west tower was also added in the middle of the fourteenth century. It is a fine church and seems to have escaped the destructive hand of Victorian restoration.

Whitchurch also once had its own castle. It was illegally built by Hugh de Bolbec, once the lord of the manor, during the Anarchy (1135–53) when the

descendants of William the Conquer, King Stephen and Empress Matilda, fought each other for the throne.

The castle was an earth and timber motte-and-bailey fortification, which was dominated by the oval-shaped motte and surrounded by a water-filled ditch. The summit of the motte would have been circled by a timber palisade with a drawbridge-equipped gatehouse to the west. The main castle buildings, probably including the Great Hall, were located on the south-east corner of the summit. To the immediate north of the motte was a triangular-shaped bailey, which would have hosted the ancillary buildings associated with such a site.

When the Anarchy ended in 1153 all fortifications built without royal authority were ordered to be destroyed. However, it is probable that Bolbec survived, as the castle was certainly extensively modified around this time including being rebuilt in stone. Thereafter little is known about the structure. The castle passed to Robert de Vere, Earl of Oxford, in 1245, by which time a village market had been established in Whitchurch.

By the time of the English Civil War, Bolbec Castle was an abandoned ruin. However, its proximity to the Royalist capital at Oxford meant it was reactivated

One of the many fine buildings in Whitchurch.

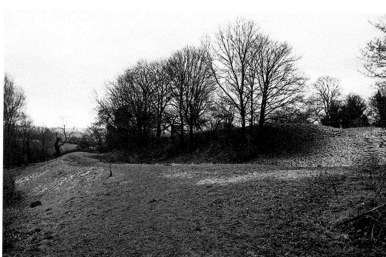

The remains of Bolbec Castle.

and garrisoned for King Charles. It was captured by Parliamentary forces in the latter stages of the war and was subsequently slighted, with the masonry remains being scavenged for local building repairs. Part of the gatehouse survived until the late eighteenth century but today only the earthwork remains to be seen.

16. Turville

There are many villages throughout Buckinghamshire that can claim to be the archetypal English rural community. That combination of a church, pub and quaint half-timbered cottages all set within an idyllic unspoiled landscape. There are a number of such villages included within in the gems of this book. However, Turville possibly comes close to supplying all the ingredients required for that quintessential picture of rural England.

Perhaps it is no surprise to learn that the Second World War, morale-boosting British movie *Went the Day Well*, a tale of 5th Column undercover Nazis attempting to invade Britain, used Turville as a location to symbolise England and what the country was fighting for.

In recent years the village was used again to represent the beauty and charm of the English landscape when it doubled as the village of Dibley in the comedy TV show *The Vicar of Dibley*, staring Dawn French.

Turville sits in idyllic Chilterns countryside some 5 miles north-west of Marlow on Thames. It consists of a perfect country pub – the Bull & Butcher – a small village green, and a much-restored twelfth-century church. Grouped around the green are period cottages dating from the sixteenth and eighteenth centuries.

Perhaps the best place to view Turville, its charms and the beautiful Chilterns location is on the top of a high ridge overlooking the village. Here one will find the

Turville village in its gentle valley.

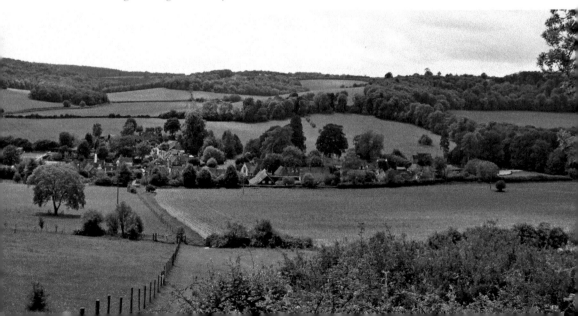

Turville windmill. Movie buffs may recognise the windmill from the film adaptation of Ian Fleming's *Chitty Chitty Bang Bang*. In the movie it was the home of mad professor Charatacus Potts and his two children. A footpath climbs from the village centre to the windmill, but, unfortunately, it is a private dwelling and not open to the public.

Despite its peace and tranquillity, Turville was the site of a curious and baffling nineteenth-century mystery. In 1871, eleven-year-old Ellen Sadler purportedly fell asleep and did not wake for nine years. The case attracted widespread attention and for a time the village and Ellen became a tourist attraction. She was admitted to hospital but after four months her condition was declared incurable and she was sent home.

Right: A quiet corner of Turville showing the cottage used in the TV comedy show *The Vicar of Dibley*.

Below: The centre of Turville bathed in glorious summer sunshine.

Ellen's celebrity grew and her family made considerable money from visitors' donations. As the years progressed with no sign of Ellen waking, speculation grew that her illness was either a hoax or caused by her mother.

By March 1873, Ellen was believed to be suffering from starvation. At first she had largely subsisted on port, tea and milk. After around fifteen months, while her mother was attempting to administer arrowroot, Ellen's jaw locked closed, forcing her parents to sustain her with 'wine and gruel using the spout of a toy teapot inserted between two broken teeth'.

Soon scepticism of Ellen's illness began to grow, for it was said that villagers sometimes saw her sitting by her window at night. Nevertheless, every effort was made to discover the deception, if any, but without success.

Ellen's mother, Anne, died in May 1880. Five months later, in November, Ellen awoke and had fully recovered. She was twenty-one and claimed to remember nothing of the previous nine years. In 1886 she married and went on to have six children. The case of Ellen Sadler has remained a part of Turville folklore, spawning tales of witchcraft and spirit possession. Curiously the cottage where the mystery unfolded became known as 'Sleepy Cottage', and was used for filming of the BBC sitcom *The Vicar of Dibley*.

17. Quainton

With its green, pond, ancient preaching cross, eighteenth-century windmill and a wealth of old cottages, Quainton has all that the visitor would hope to find in an English village. Its name is Old English and means 'Queen's Estate' ('Cwen tun'). It is not known to which queen this refers, but it was possibly Edith, the wife of King Edward the Confessor. Known as 'Fair Edith', she held manors in this part of Buckinghamshire, while her husband had a palace at the nearby village of Brill.

A period photo of Quainton showing the green and windmill.

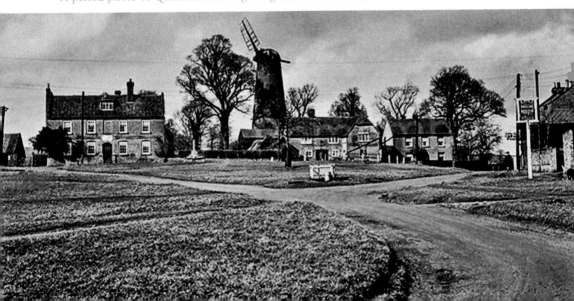

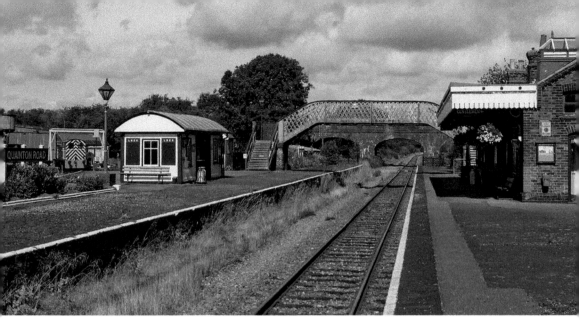

Quainton Road railway station is now used as the Quainton railway centre.

The village was originally known as Quainton Mallet, a name that refers to the Mallet family, who were lords of the manor from 1066 until around 1348. They had associations with the Knight Hospitallers, an organization founded in the eleventh century who provided care for the sick or injured pilgrims travelling to the holy land on crusade. They are also thought to have rebuilt Quainton church in 1340 The Hospitallers erected the cross on the village green, the base and shaft of which still remain. The Church of St Mary and Holy Cross contains many fine monuments including the impressive 1689 tomb sculpture of Sir Richard Winwood and his wife.

Another of Quainton's eye-catching structures is its windmill. The 70-foot (20-m) six-storey brick tower mill was built in 1830–32, and is one of the most visible buildings in the village. Derelict for most of the twentieth century, it has now been restored and can grind wheat into flour. The windmill was built by James Anstiss and it is still owned by the Anstiss family. It has the distinction of being the tallest windmill in Buckinghamshire.

For the lover of steam trains Quainton has a perfect treat: the Buckinghamshire Railway Centre. Quainton road station was opened in 1868 as part of the Aylesbury & Buckingham Railway. In 1891 it was taken over by the Metropolitan and Grand Central Railway. The (GCR) ran trains from the north of England, and Quainton Road became a significant junction at which trains from four directions met, making it the busiest of the Metropolitan Railways's rural stations.

From 1923 until 1948 the line came under the control of the London and North Eastern region, until nationalisation in 1948 brought it under the control of British Railways. Following the Beeching cuts its passenger service was withdrawn in 1963, with its good service being curtailed three years later in 1966.

Happily in 1969 the Quainton Road Society was formed with the aim of preserving the station. Their efforts have proved nothing but a huge success and today the fully restored station has become a much-visited museum with many preserved locomotives, carriages, coaches and a miniature railway for children. The line remains connected to the railway network, and freight trains still use the line, plus passenger trains still call at the station for special events organised by the railway centre.

18. Great Missenden

Great Missenden is certainly a gem of a Buckinghamshire village and well worth a visit. However, a word of caution: refrain from doing so on a busy rush-hour morning during school term time between 7.30 and 9.30, when the village main street becomes a noisy throng of traffic. During the school holidays Missenden is a much more sedate place. However, I recommend you plan your trip for a sunny Sunday morning when the village still slumbers and the chime of its church bells sounds out over the rooftops and the cars and buses have a day off.

Great Missenden lies at the head of the Misbourne valley just a few miles from Little Misenden. The name is thought to derive from the Old English words 'Mysse' and 'Denu', meaning 'the vale where the water plants grow'. By 1086 it was recorded in the Domesday book as Missenden. Reminders of eighteenth-century coaching inns along the high street recall a time when Missenden was on the main route from London to the north through the Aylesbury gap.

The main street of the village is lined with many attractive half-timbered buildings dating from the sixteenth to the eighteenth centuries. Celebrated children's author Roald Dahl lived in Missenden at Gypsy House from 1954 until his death in 1990. Dahl used some of the locations in the village as settings for his stories including the house where Sophie meets the BFG, Big Friendly Giant. Luckily for all those youngsters and adults who love the tales of Roald Dahl an old sixteenth-century high street coaching inn has been converted in to a museum dedicated to his work.

The village is overlooked by the medieval parish church of St Peter and St Paul. Its position away from today's centre suggests there was an earlier settlement around the church, which was moved to its present location in the early Middle Ages.

Bunting and flags adorn the High Street.

One of the exhibits in the Roald Dahl Museum. Dahl was a Missenden resident for many years, and based some of his stories on locations throughout the village.

Church Street, which leads up to the Church of St Peter and St Paul, is lined with attractive seventeenth- and eighteenth-century cottages. Further along, the route up to the church becomes a narrow lane, which then crosses over a bridge spanning the A413. The road was intended to take traffic away from the centre of the village, which it partly does. Passing above the speeding cars makes for an interesting journey to the church, but it is well worth it for the cemetery contains the grave of Roald Dhal and there are views back over the valley to be enjoyed.

Missenden once contained an abbey, which was founded in 1133. It was abandoned in 1538 following the Dissolution of the Monasteries, and the remains were incorporated into a Georgian mansion, which is now a conference centre and college.

19. Little Missenden

Little Missenden is a prized beauty spot just off the A413 Aylesbury to Amersham road. Despite the nearby speeding traffic, Little Missenden has managed to retain its peace and quiet, and oozes charm and tranquillity, sitting as it does in the valley of the River Misbourne, and surrounded by perfect Chilterns scenery.

A single street winds its way past the first of its two pubs, the Crown, Little Missenden house, built in 1748 next to some pretty brick cottages by a tiny green, and the Red Lion Inn, where the river slides noiselessly through the pub's garden and on to an impressive Jacobean manor house.

Here the road branches off south past the old rectory, half-timbered cottages and a converted farm to exit the village along a narrow lane through woods and low hills that lead up to the suburb of Holmer Green, an outlying district of the town of High Wycombe.

The village's main street continues past the manor house and on to the compact but architecturally interesting Church of St John the Baptist, which is a building well worth spending time exploring.

The church dates from the mid-eleventh century. However, the church guide states that the building was established during the late Saxon period, and within there is evidence that the structure dates back before 1066.

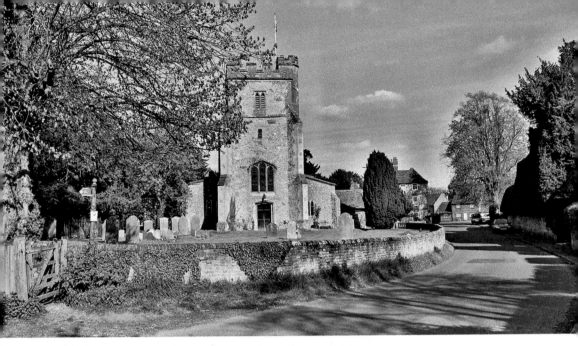

Above: Late afternoon sunshine bathes the west approach to the village.

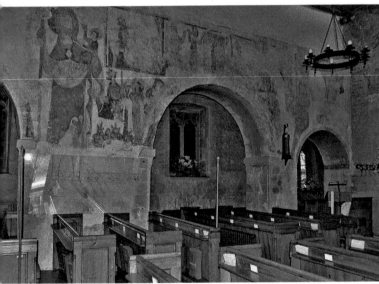

Left: The interior of Little Missenden church showing thirteenth-century wall paintings.

The round arches of the nave arcade are Norman, but above there are the remnants of small windows cut into an earlier wall. The tall proportions of the nave also point to a Saxon date. The architectural lineage of the church continues in the early English chancel with three lancet windows and the Perpendicular fourteenth-century tower and tower arch.

On exiting the church, for the mildly energetic there is a pleasant short walk. If we turn left out of the churchyard and head towards the junction by the manor house, a right turn will take us up to a stile and gate that leads into a field. The footpath continues across and up to a second gate, which opens out on to a narrow track. Turn right and it will take the walker up to the busy Wycombe–Amersham road. A left turn will lead us back down into the village and the choice of two very welcoming pubs.

The village green and the Red Lion pub.

Little Missenden is truly a delight of a village. It can be explored and enjoyed throughout the year. However, my own personal preference is to take in its timeless pleasure on a summer's afternoon. Sitting in the sunlit churchyard as the tower clock strikes three, one can hear the twitter of birdsong, the gentle breeze caressing the trees and the distant chop of the woodman as he collects his fuel for the winter fire – everyday village sounds that make for a wonderfully fulfilling experience.

20. Haddenham

Haddenham is a village of contrasts. In part it is a large semi-industrial location with new housing estates and scattered engineering works. Yet it is a view that gives a totally misleading impression of the place as a whole, for within the centre this large pretty medieval village is complete with a duck pond, seven pubs, a twelfth-century church and the perfect village green with its war memorial, all of which are surrounded by just as perfect cottages from various periods. Indeed it was recently voted the fifth best place in Britain to live.

Most of the houses are constructed from Wychert or whitchet, a method of building with a white clay mixed with straw, which are then thatched and topped with red clay tiles. Indeed Haddenham is one of only three villages in England where this house-building technique is used. The village is also famed for its breeding of Aylesbury ducks.

The village is Anglo-Saxon in origin and probably takes its name from a one-time tribal leader called Haeda, who set up his 'ham', or 'homestead', on the site. It is possible that the first villagers were members of the Hadding tribe from Haddenham in Cambridgeshire. It is known that the first Anglo-Saxons to settle in the Vale of Aylesbury were followers of Cuthwulf, from Cottenham in Cambridgeshire, who marched south-west to the Thames after routing the British in battle in 571. The Domesday Book records the manor as Hedreham in 1086, but by 1142 it was noted as Hedenham.

The Church of St Mary is of special importance. Parts are in the Norman style of the twelfth century. Other features may be from the original Saxon church including the font, which has a drawing of a dragon imprinted on it. The tower is Early English Gothic and is said to be the finest demonstration of Early English architecture in the county.

Haddenham is a true delight, and the most enjoyable way to take in its charms is on foot. My wife and I recently visited the village and, as we sat by the pond taking in the sunshine, we both noted the peace, calm and pleasure of this Buckinghamshire gem. She remarked that it was like a Hollywood film set depicting the idyllic English village. I agreed, only adding that Haddenham was real.

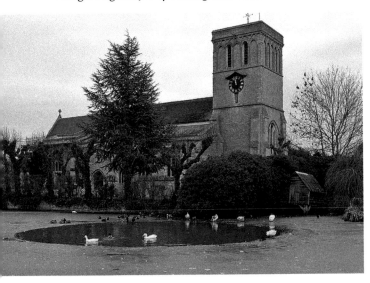

Left: Haddenham church in its delightful winter setting.

Below: The perfect village green and pond.

21. Hambleden

Hambleden is one of the most attractive locations in Buckinghamshire. It sits perfectly placed 4 miles west of Marlow in a valley of the Chilterns, whose beech-clad hills seem to break like waves down the surrounding slopes. The core of the village is around a small triangular green, with the church of St Mary on the north side. The village name is Anglo-Saxon in origin, and means 'crooked or irregularly shaped hill'. It was recorded in 1015 as 'Hamelan dene', and in 1218 it was the birthplace of St Thomas Cantilupe, the Lord Chancellor of England and Bishop of Hereford. He was canonised by Pope John XXII in 1320 and was the last Englishman to be made a saint before the Reformation.

The Church of St Mary originally dates from the twelfth century but was much altered in the thirteenth and fourteenth centuries. The central tower collapsed in 1703 and was rebuilt in 1721. It was then raised and altered in 1882. The chancel aisles and vestry were added in 1859, with further restorations in the late nineteenth century, making the church an almost Victorian building. Nonetheless it does contain a few monuments dating from the sixteenth and seventeenth centuries, in particular the 1633 memorial to Sir Cope d'Oyley.

Many of the cottages and houses are of brick and flint, and so regular in style they might almost have been built in one decade. In fact they date from the seventeenth to the twentieth century. The Elizabethan manor house opposite the church was built in 1603 for Emanuel, 11th Baron Scrope, who became Earl of Sunderland. Charles I stayed there overnight in 1646 while fleeing from Oxford.

A candidate for one of Bucks' most beautiful villages.

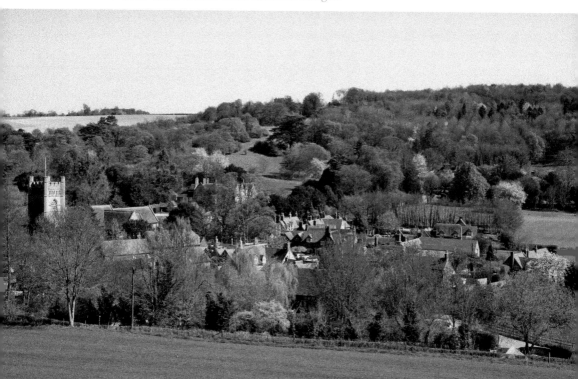

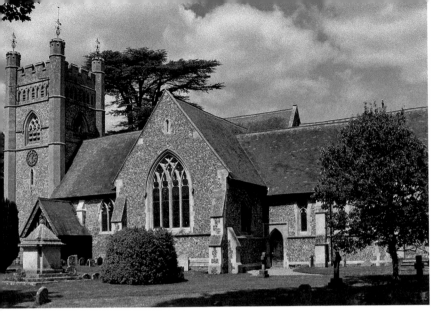

The mostly Victorian Hambledon church.

The manor house is also the birthplace, in 1797, and former home of Lord Cardigan, who led the ill-fated Charge of the Light Brigade during the Crimean War in 1854. The sea chest he took to the unfortunate Russian campaign can still be seen in the church.

22. Long Crendon

Long Crendon is a picture-postcard village of thatch and timber cottages. The most notable is the courthouse. Now owned by the National Trust, it was possibly built in the fourteenth or fifteenth century as a store house used by wool merchants. Curiously it later became a meeting place for the scholars of All Souls College, Oxford, who were granted the income form the village. Crendon has a long history, as shown artefacts found here from the Iron Age, Roman and Saxon periods show.

It was the 'caput', or 'centre', of administration of the feudal lands held by Walter Gifford (d. 1102), who was created Earl of Buckingham by William the Conquer. The manor house in the village was once a great building that housed the later earls of Buckingham and over the years the various manorial estates in the village have passed through the hands of the Crown, the University of Oxford, the earls of March and the Marquis of Buckingham. The latter is now the lord of the manor.

The courthouse near the church dates from around 1485 and provided accommodation on the ground floor for the poor and on the upper floor for the meetings of the manorial court. The court, which all the tenants of the manor were required to attend, dealt with minor offences and the transfer of tenancies. At one end of the building was the kitchen in which dinner was prepared for members of the court. In 1900 the courthouse was the second property to be acquired by the National Trust.

Once again for the Buckinghamshire church lover Long Crendon is a gem. There was a church here at least as early as the Norman period, but the building we see today

A quiet corner of the village showing brick, half-timbered and thatched cottages.

The late fifteenth-century courthouse.

is the result of a complete thirteenth-century rebuild, when Long Crendon was under the patronage of Notley Abbey. The oldest part is the chancel, which dates to around 1235, while the rest of the structure dates to around 1265. In 1335 the north aisle was widened and a north porch added. The central tower and west wall of the nave were rebuilt in the sixteenth century.

In the south aisle is a finely moulded thirteenth-century doorway. Also in the south aisle is a fifteenth-century window and a fourteenth-century font topped by a carved Victorian cover. The font was carved around 1380, with quatrefoil panels on the sides and angel figures at the corners.

St Mary the Virgin Church also contains a memorial of note. The Sir John Dormer monument in the south transept dates from 1627. The tomb was designed by Nicholas Johnson and is set behind a contemporary iron railing. Dormer's effigy shows him as a knight in full armour, and is set in a classical recess flanked by Tuscan columns. Every surface of the memorial seems to glitter with gilding, and the effect is quite stunning – a Buckinghamshire gem worth stopping for.

23. West Wycombe and the Hellfire Club

West Wycombe lies some 2½ miles from the centre of High Wycombe along the A40. It is a pleasing location containing many fine half-timbered buildings dating from the fifteenth to eighteenth centuries. It is here, in this rural charm, that ghosts, a murder, pagan worship and the debauchery of eighteenth-century titled gentry are all inextricably linked with this seemingly peaceful English village, its grand manor house, the church, which stands proudly on top of its ancient hill, and the infamous activities that are said to have taken place within the labyrinth of caves that snake their way beneath.

West Wycombe Hill could well be described as a place perfect for the mysteries of Britain's pagan past. The site has been continuously occupied for thousands of years. A Bronze Age settlement is widely believed to have first existed here, and research has shown that a pagan temple was constructed in a similar style to Stonehenge. The Romans also built their own settlement and religious temple here. With such an ancient and dark past, it seems appropriate that the one man who would become synonymous with West Wycombe took eagerly to the pleasures, rituals and rakish delights of eighteenth-century decadence.

In 1724, Sir Francis Dashwood (1708–81) inherited the estate and set about remodelling his house, West Wycombe Park. The house, built and added to between

Imposing and beautiful West Wycombe Hill.

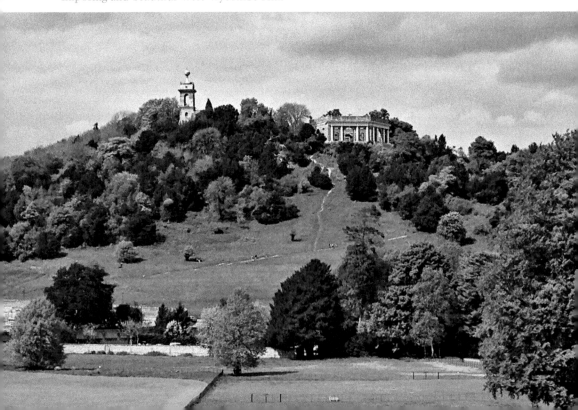

1740 and 1800, encapsulates the entire progression of British eighteenth-century architecture, from Palladian to neoclassical, and is set within a landscaped park containing temples and follies.

The baronet didn't limit his ideas and plans to just his home and gardens. In 1751 the fourteenth-century Church of St Lawrence disappeared within Dashwood's rebuilding of the interior, which was styled on the third-century Temple of the Sun of Palmyra in Damascus. Only the medieval tower was retained, which itself was considerably heightened and topped by a great golden ball fitted with benches, and was large enough to contain six people. It was in the golden ball that Dashwood and his cronies drank the night away as they played cards and related bawdy stories. In 1765 the vast hexagonal Dashwood mausoleum was built to the east of the church. Its design was derived from the Constantine arch in Rome, and it was where the Dashwood memorials would be erected.

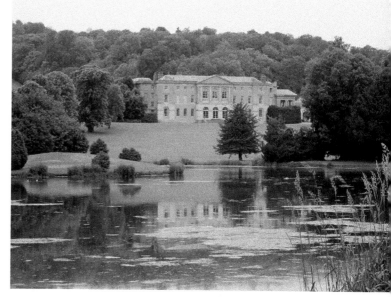

The stately West Wycombe Park, the Dashwood family seat.

The Dashwood Mausoleum atop West Wycombe Hill.

Yet of all Sir Francis grand schemes for West Wycombe, perhaps the most ambitious was undertaken between 1748 and 1752 with the extension of a series of ancient chalk tunnels under West Wycombe Hill into an elaborate labyrinth of caves and chambers. The descent through the passageways and underground chambers concluded by crossing a subterranean river named the Styx, which entered into the inner temple. According to Greek mythology the River Styx separated the mortal world from the immortal world, and the subterranean position of the Inner Temple directly beneath St Lawrence's Church was supposed to signify Heaven and Hell.

Between 1750 and 1766 the Hellfire Club held their nefarious meetings in the caves below the hill. Their numbers included artist William Hogarth, political activist John Wilkes, John Montague, 4th Earl of Sandwich, poet Paul Whitehead and possibly, at times, American Benjamin Franklin. They greeted each other as brothers and dressed as monks, while their accompanying ladies were attired as virginal nuns.

Possibly some form of satanic or pagan ritual mimicry took place, but more likely they indulged in drinking, gambling and whoring. Following Dashwood's death in 1781 the caves fell out of use and were left derelict. Today the caves, along with West Wycombe House, are open to the public.

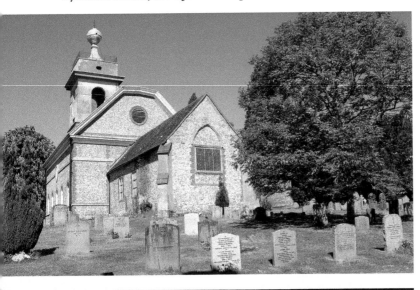

The Church of St Lawrence.

The eerie and mysterious Hellfire Caves.

Stately Home Gems

24. Hartwell

Although Hartwell dates back to Saxon times, the core of the present building was constructed in the seventeenth century for the Hampden family, and then the Lee family. The Lees were of ancient Buckinghamshire stock, and acquired Hartwell in 1650 by marriage in to the Hampdens.

Between 1809 and 1814 the owner of the house, Sir Charles Lee, let the mansion to the brother of the last king of France, known as Louis XVIII. Following the French Revolution the monarchy was abolished in France and the king and his queen were forced into exile. Louis was joined in his miserable expulsion at Hartwell by a collection of impoverished European royalty. His niece, the Duchesse D'Angoulême, daughter of Louis XVI and Marie Antoinette, his brother, the Comte d'Artois, later Charles X, and Gustavus IV, the exiled King of Sweden, all had to make do with what this Buckinghamshire mansion could provide. Following the defeat of Napoleon at the Battle of Waterloo in 1815 and the restoration of the monarchy, Louis XVIII proclaimed the declaration of Hartwell and signed the document accepting the French crown in the library.

Hartwell House, once home to the last king of France.

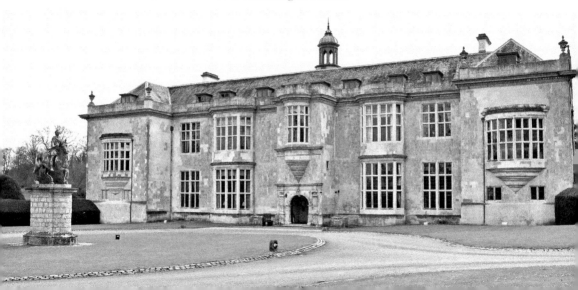

In 1827, Dr John Lee, an astronomer, inherited the house and during his ownership the British Meteorological Society, now the Royal Metrological Society, was founded in the library in 1850. The telescope used at Hartwell observatory was designed by William Henry Smyth, whose daughter, Henrietta Grace, married the Revd Professor Baden Powell. One of their children was Robert Baden Powell, who, in 1907, founded the Boy Scout movement. The house remained a private residence until 1938, when, at risk of demolition, the estate was acquired by the philanthropist Earnest Cook, the grandson of travel entrepreneur Thomas Cook.

25. Chenies

Chenies is a curious name for a compact pretty village on the Hertfordshire border. In the thirteenth century it was known as Isenhampstead Chenies to distinguish it from nearby Isenhampstead Latimer, the names of two families who were lords of their respective manors. In the nineteenth century the prefix was dropped.

It is a place of contrasts. Essentially a Buckinghamshire estate village once owned by the Russell family, who became earls and later dukes of Bedford, it consists mainly of nineteenth-century rebuilt cottages, a pleasant green complete with a village water pump, and a local pub, The Bedford Arms. Yet its chief glories are from the medieval and Tudor periods.

It was a shield bearer to Edward III, Thomas Cheyne, who first gave his name to the village. It was his descendent, Sir John Cheyne, who built Chenies manor house in 1460. In 1526 the village and manor passed by marriage to the Russell family. It was John Russell, 1st Earl of Bedford, who set about improving the house between 1530 and 1550 as his home and enlarging it to the size and standard needed to house the royal court, allowing him to host visits from the king.

Henry VIII is known to have visited the manor several times, with a court and retinue that probably amounted to 1,000 people. In 1534 he attended with Ann Bolyen and Princess Elizabeth.

In 1541 Henry came on a visit with Catherine Howard, his fifth wife. Catherine was carrying on an affair with a member of the court retinue, Thomas Culpepper. It was possibly at Chenies that Archbishop Cranmer's secret informers gathered evidence of Catherine's infidelity, evidence that resulted in her execution for treason only a few months later.

Like her father, Elizabeth I visited Chenies several times. This was perhaps the high point for the house; it was at the centre of political life and enjoyed royal patronage. However, after Elizabeth's death, the manor fell upon hard times. Parliamentary troops used the long gallery as a barracks during the Civil War.

By around 1608 Woburn Abbey in Bedfordshire had become the principal family residence. Thereafter Chenies became increasingly neglected. The manor dwindled in importance and was let out as a farmhouse. In 1750, the house was described as being 'in piteous fragments', and a surveyor recommended that the entire structure be pulled down. Happily his advice went unheeded. Though parts of the house were

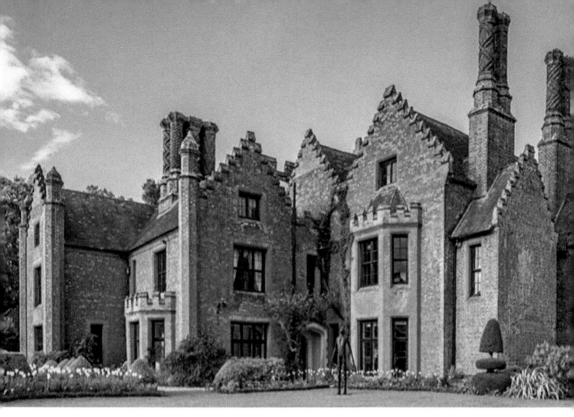

Chenies Manor.

dismantled, most was saved, and the glorious Tudor gatehouse and Henry VIII Wing were restored. In 1829 Edward Blore modernised the house for the Russells, and since then it has remained blessedly unaltered.

Despite the families move to Woburn, the Russells continued to be laid to rest in Chenies parish church, St Michaels. It is the manor house and the church that are the village's chief attractions today.

The house that greets you as you pass through the Tudor gatehouse is L-shaped, with the entrance at the meeting of the wings. Within, the main ground-floor room is the parlour, which is graced with a lovely beamed ceiling and warmed by a wide fireplace. Many of the downstairs rooms are filled with Georgian and later furniture, though much of the decor has its roots firmly in Tudor times. The upper floors contain a long gallery, with exhibits on the family's long history at Chenies.

The house is set in extensive gardens with a mix of wide lawns, a summer house, a kitchen garden, a medicinal garden and a restored well house. The manor house and gardens are open to the public.

Chenies' other main attraction is sadly not open to the public, yet it is still possible to glimpse part of it. Although St Michael's Church dates from the fifteenth century, it was heavily restored in 1861. Its main point of interest is the Bedford Chapel. It was built in 1556 and contains a fantastic collection of funerary sculpture covering almost five centuries. It is here that the Russells are laid to rest. The chapel is kept locked and the visitor has to be satisfied by viewing the display of monuments through a glass screen from the nave. Ironically, it is this private segregation of the chapel from the rest of the church that has allowed the Russell tombs to remain in an astonishing, unspoiled condition; they could have been sculptured and painted yesterday.

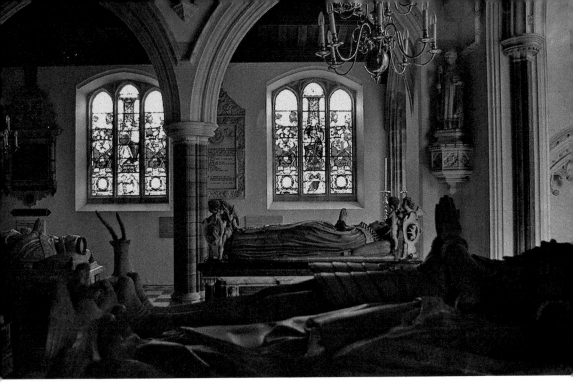

The astonishing Bedford Chapel within St Michael's Church.

26. Chequers

The most well-known address associated with the British prime minister, apart from No. 10 Downing Street in London, is undoubtedly Chequers. It sits in delightful Chilterns countryside midway between the towns of Princes Risborough and Wendover. The house was built in 1565 by William Hawrtrey, probably on the site of an earlier building.

The curious name 'Chequers' may derive from an early owner of the manor of nearby Ellesborough in the twelfth century, Elias Ostiarius. The name 'Ostiarius' meant an 'usher of the Court of the Exchequer'. Elias Ostiarius' coat of arms included the chequer board of the Exchequer, so it is possible the estate is named after his arms and position at court. An alternative explanation of the name is that the house is named after the chequer tress (*Sorbus torminalis*) that grow in its grounds. Its royal connections date back to the Elizabethans. William Hawtrey acted as custodian for Lady Mary Grey, the sister of the doomed nine-day queen Lady Jane Grey, the great grand-daughter of Henry VII.

Mary Grey had married Thomas Keyes without her families consent and was banished from court by Elisabeth I. To ensure she did not have any descendants she was confined to Chequers for two years. She never saw her husband again. Keyes was imprisoned in the Fleet Prison in London. He was released in 1569, but his health had been broken by the conditions of his imprisonment and he died shortly before 3 September 1571.

The heartbroken Mary would, in time, return to royal favour and raise Keyes' two children from his first marriage. However, the years had taken their toll and she died on 20 April 1578, aged only thirty-three. She was buried in Westminster Abbey.

The house passed through several families from the sixteenth to the eighteenth centuries. In 1715 the then owner of the house married John Russell, a grandson of Oliver Cromwell. It would seem appropriate that the country seat of the incumbent Parliamentarian and prime minister of Britain is a house that is well known for its connection to the Cromwell family. Today Chequers contains one of the largest collections of art and memorabilia pertaining to Oliver Cromwell.

In the nineteenth century the new owners, the Greenhill-Russell family, following on from the Victorian love of all things Gothic, made alterations to the house in that style. The Tudor panelling and windows were removed and battlements with pinnacles installed. However, towards the end of the nineteenth century, the house passed through marriage to the Astley family, and between 1892 and 1901, Bertram Astley set about restoring the house to its Elizabethan origins.

During the First World War the house became a hospital and then a convalescent home for officers. In 1912, after the death of the last of the house's ancestral owners Henry Delavel Astley, it was purchased by Arthur Lee and his wife, Ruth. The Lees had no children and decided to bequeath the house to the nation as a country retreat for the serving prime minister. After long discussions between the Lees and the then Prime Minister David Lloyd George, Chequers was given in trust to the nation under the Chequers Estate Act 1917. The gift included a library, historical papers and manuscripts and a collection of Cromwellian portraits and artefacts. From then on, Chequers was to be used as the official residence and retreat of successive British prime ministers in perpetuity, enabled by the Chequers Estate Act 1917. The Lees left the property in January 1921, and Lloyd George was the first prime minister to use the property.

The house has been the country residence of British prime ministers since 1921.

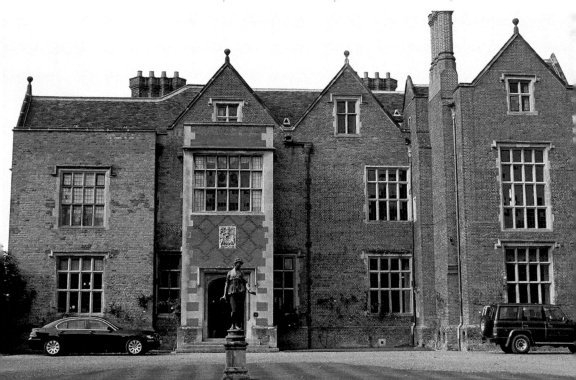

27. Claydon House

In his popular book *England's Thousand Best Houses* Simon Jenkins opens his description of Claydon House with the words 'it contains the most stunning interiors in England'. He is not wrong. Once you've seen the interiors for yourself you may find that he has understated matters.

First the History. The house sits on a rise looking over peaceful parkland, and is flanked by a wonderful medieval church. Within the church is a huge monument to Sir Edmund Verney, who was killed at the Battle of Edgehill in 1642. Edmund Verney was knighted by James I and VI in 1611. From 1620 he made his family home at Claydon House. In 1623, he accompanied the future Charles I to Spain to court the Infanta Maria.

On returning to England he became MP for Aylesbury in 1629. However, with the approach of the English Civil War he found his loyalties in painful conflict. While personally loyal to the Charles I, he often found himself in political opposition to the king. Yet, upon the outbreak of war, Verney remained true to his master and friend, and decided to side with the Royalists, while his eldest son, Ralph, joined the Parliamentary forces. Edmund was made the standard bearer of the royal army. Tragically he was killed at the Battle of Edgehill in 1642. According to the tradition of his family, his body was never identified except for his severed hand, which was found still grasping the banner.

Claydon is a Georgian home notable for its association with Florence Nightingale and its interior's truly remarkable carved decoration. The house itself is an

The west front of Claydon House.

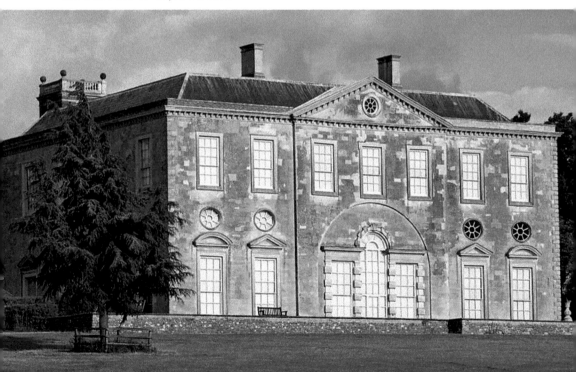

The ornately
carved interior.

unpretentious eighteenth-century rectangle in the classical style, with a large porticoed entrance.

In the nineteenth century the 2nd Baronet Verney married Parthenope, sister of Florence Nightingale. Florence was a frequent visitor to Claydon, and her bedroom on the second floor contains many of her personal effects and momentoes including letters, clothing, and her travelling communion set.

If the exterior is unremarkable, the interior is beautiful. The rococco decoration is probably the most striking in any English stately home. A series of rooms are embellished in Chinese and Gothic style, with incredibly ornate carvings.

Claydon House is often referred to as a Georgian jewel. It is a fascinating testament to eighteenth-century extravagance, and perhaps such extravagance is befitting of the gardens and park that surround the house. They were laid out for the 2nd Earl Verney by a pupil of Capability Brown in the eighteenth century.

28. Cliveden House

Cliveden House stands on the banks of the River Thames near Taplow in south Buckinghamshire. Designed in the English Palladian style by Sir Charles Barry in 1851, it is the third building to occupy the site. The first, built in 1666 and home to George Villers, 2nd Duke of Buckingham, burned down in 1795 and the second house, constructed in 1824, was also destroyed by fire in 1849. Throughout its history the house has been associated with the titled, rich and famous, yet its fame or notoriety today stems from its links with the Astor family.

In 1893 the estate was purchased by very wealthy American William Waldorf Astor, later becoming 1st Lord Astor, who lived at Cliveden as a recluse after the

death of his wife. He gave the house to his son, Waldorf, as a wedding present following his marriage to American socialite Nancy Langhorn in 1906.

Although she was not the first woman to be elected to parliament, Nancy Langhorn Astor was the first female to sit in the House of Commons when she was chosen to represent Plymouth in November 1919. She achieved little as an MP and today her reputation is mostly remembered with her association with 'The Cliveden set', as much a disparate group of individuals as one could imagine. They included film stars, politicians, world leaders, writers and artists. The heyday of entertaining at Cliveden was between the two world wars when the Astors held regular weekend parties, which were attended by such people as Charlie Chaplin, Winston Churchill, Joseph Kennedy, the father of President Robert Kennedy, Ghandi, Lawrence of Arabia, Franklin D. Roosevelt and Rudyard Kipling.

During both world wars the grounds of the house were used as a military hospital by the Canadian Red Cross. Attached to the military hospital and within the grounds Cliveden War Cemetery was established. There are forty-two Commonwealth war graves, forty from the First World War (mostly Canadians) and two from the Second World War, beside two American service war graves from the First World War. After hostilities ceased the Canadian Red Cross Memorial Hospital was built. It continued as a nursing school and maternity unit until its closure in 1980.

In 1942, the Astors gave Cliveden to the National Trust with the proviso that the family could continue to live in the house for as long as they wished. Should this cease, they expressed the wish that the house be used 'for promoting friendship and understanding between the peoples of the United States and Canada and the other dominions'. With the gift of Cliveden, the National Trust also received one of the Astons largest endowments (£250,000 in 1942, which is equivalent to £10,692,930 today). The Astor family ceased to live at Cliveden in 1968, and today the house functions as an exclusive hotel.

The stately front of Clivedon.

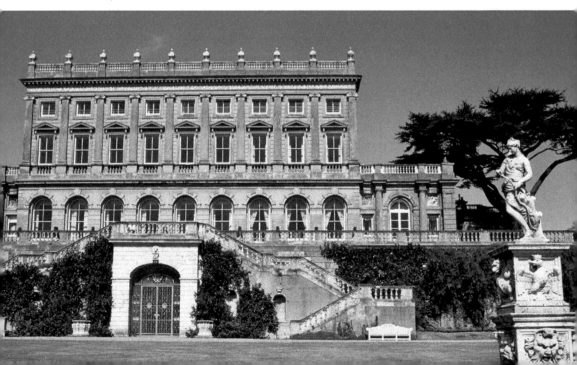

29. Gayhurst

Gayhurst is a small village in the north of Buckinghamshire on a busy B road between Newport Pagnal and Northampton. The village name is an Old English word meaning 'the wooded hill where the goats are kept'. Indeed one might easily drive through and not give the location a second thought. However, Gayhurst contains two not to missed gems.

Gayhurst House and its associated church are architecturally and historically two of the most important buildings in Buckinghamshire. The present house, dating form 1597, was built on an earlier structure of 1520, which was said to be the former home of Sir Francis Drake, who sold it to William Mulso. The house was completed by Mulso's son-in-law Sir Everard Digby in the early years of the seventeenth century. It is an impressive late Elizabethan structure, but has seen many alterations over the years from 1750 up to the late nineteenth century. The house and church are to be found off the main B526 within a beautiful landscaped park, which was laid out by Capability Brown in 1763 and remodelled by Humphrey Repton some thirty years later.

It is perhaps the historical connections with Gayhurst House that are the most intriguing for the visitor. Sir Everard Digby was one of the conspirators involved in the Gunpowder Plot to blow up James VI and I in 1604. Even though Digby had been knighted by King James, he otherwise disagreed passionately with the monarch's policies towards his faith as a Catholic. Although the plot was hatched at Ashby St Ledgers in Northhamptonshire, the home of its chief protagonist, Robert Catesby, on several occasions the conspirators, including Guy Fawkes, met at Gayhurst.

As we know the plot failed and the would-be assassins were hunted down. Sir Everard Digby was arrested and, following his capture, was tried separately from the others on 27 January 1606. He was the only plotter to plead guilty. As he was a nobleman he requested that he meet his end by the headman's axe.

Gayhurst House, once home to Sir Francis Drake, and where the Gunpowder plotters conceived their plan to blow up Parliament.

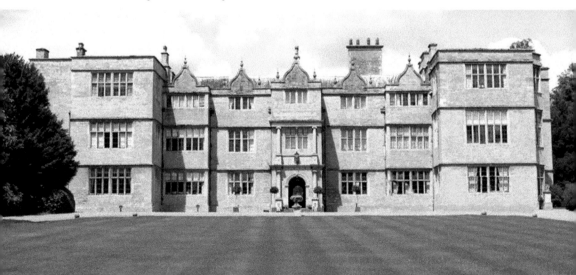

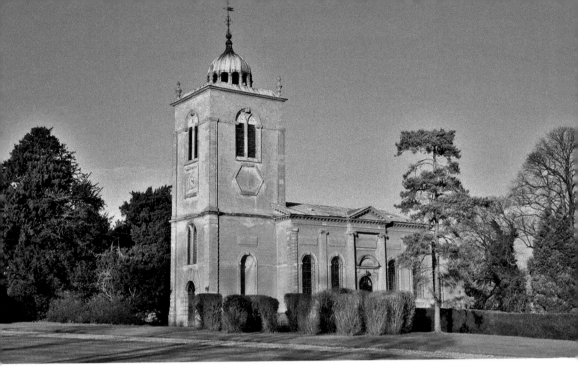

Above: The beautiful and unrestored Gayhurst church.

Below: The striking Wright monument.

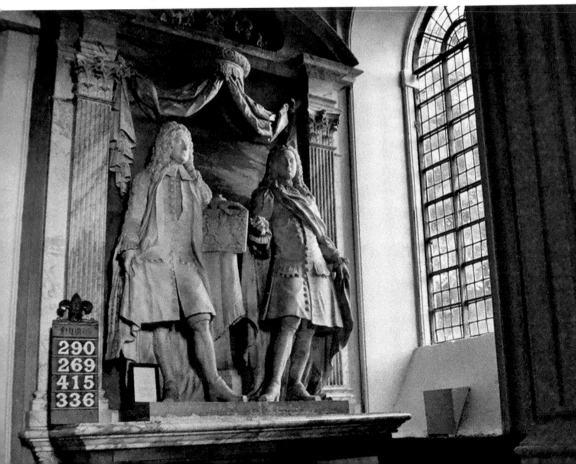

In spite of the Digby family's disgrace at the time, Sir Everard's widow was able to retain the property. Ironically, both sons – John and Kenelm – became fervent Royalists during the English Civil War in the 1640s.

During the Civil War, Parliamentary troops were billeted at Gayhurst and an inscription in the porch showing an 'X' and the date 1649 is said to have been scratched into the stone by a bored Roundhead recording the execution of Charles I.

In 1704 the house and estate was purchased by Nathaniel Wright. It was the Wright family who built the present church. The building is a gem for the church crawler for it retains all of its original fittings. All around the walls is oak panelling. Within the chancel there is a gilded oak reredos with large panels upon which are painted texts from the Ten Commandments, the Lord's Prayer and the Apostles' Creed. The nave is entirely seated with box pews, with a single large pew for the Wright family.

The churches crowning glory is the Wright monument set against the south east wall of the nave. It depicts George Wright and his father, Nathaniel. The two men stand as they were modelling their Georgian costumes. Sadly they were to both die within four years of one another, Sir Nathan in 1721 and his son in 1725. The monument was probably erected in 1730, and is considered the best sculpture of its type in England.

30. Hughenden Manor

Hughenden Manor stands just outside the centre of High Wycombe. This grand stately house was the former home Victorian politician and statesman Benjamin Disraeli. The house was built in the late eighteenth century, but it is possible that a building has existed on the site since the eleventh century. The manor of Hughenden is first recorded in 1086 when it was assessed for tax at ten hides. The name is probably derived from the Old English personal name 'Huhha' or 'Hucca' and 'denu', meaning 'Huhhas valley'. During the Second World War the house was used as a secret intelligence base code-named 'Hillside' where Air Ministry staff analysed aerial photography of Germany and created maps for bombing missions, including the famous Dambusters raid in 1943.

Disraeli, who was a favourite of Queen Victoria, became prime minister in 1868, and again between 1874 and 1880. He purchased the house in 1848 from two political allies with a loan of £25,000, equivalent to almost £1.5 million today. The manor was remodelled in the Gothic style, and it remained the statesman's home until his death in 1881.

It was soon after Disraeli's death that reports that his ghost had been seen walking the rooms and staircase of the house started to circulate and have continued to do so. Among those who have claimed to have witnessed the spectre was a visiting member of the Ghost Club, Britain's oldest psychical research organisation. During a tour of the house one of the team wandered away from the main party into the study. She was examining a painting when out of the corner of her eye she caught a movement. Turning, she saw the ghost of Disraeli staring at her. Other occasions his wraith has been seen on the main staircase with papers in his hand.

It seems to have been a favourite spot for another woman visitor once came upon him standing near the portrait of himself, which stands on the staircase. She reported that the ghost stood for a time oblivious or unaware of her presence, then dissolved as approaching voices were heard. The same day another Ghost Club member glimpsed a figure going down the stairs, which she thought was a man dressed in Victorian clothes. When it reached the bottom it vanished. Paranormal aromas have also been reported at Hughenden. On several occasions a member of staff on entering a study, which contains Disraeli's peers' robes, shoes and sword, has distinctly smelled the scent of perfume or cologne. The politician, who was looked upon as a dandy, often dressed in flamboyant clothes and wore the Victorian equivalent of aftershave.

Today the manor house is open to the public.

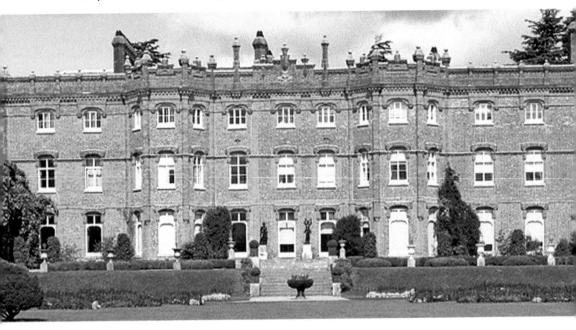

Above: Hughenden Manor.

Left: Disraeli's study.

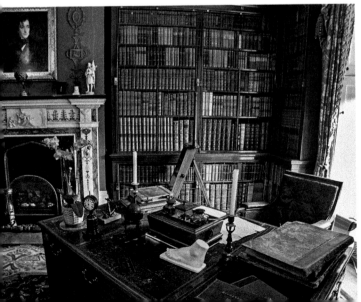

31. Waddesdon Manor

Waddesdon Manor was begun by Baron Ferdinand de Rothschild in 1874 and completed in 1889. The Rothchilds were a prominent and immensely wealthy family of bankers. Money was no object in their designs for the house they created at Waddesdon. For their plans they turned to their European heritage. French architect Gabriel-Hippolyte Destailleur was employed to design a huge hilltop house looking out over a pastoral landscape. The house, built using Bath stone, is a mixture of French traditional chateau elements, with round turreted towers soaring high above a mansard roof. A broad avenue leads up the hill to the house, and formal terraced gardens behind the house open out into parkland. The manor looks as if a piece of France has been dropped down in the middle of the Chiltern Hills.

The construction of the house was a massive project, taking fifteen years to complete. Water had to be brought in from 14 miles away, and a special steam-powered tramway was built to haul building materials up the hill, which had to be levelled before building could begin.

The exterior of the house is impressive enough, but it is ably matched by the lavish interior. Built in the style of eighteenth-century French architecture, the richly decorated rooms are augmented by plastered and painted ceilings. They contain an incredible collection of fine art, furniture, ceramics and carpets. There is an inlaid writing table made for Marie Antoinette and a carpet commissioned by Louis XIV that is nearly 1/4 mile in length.

The impressive French château style of Waddesdon Manor.

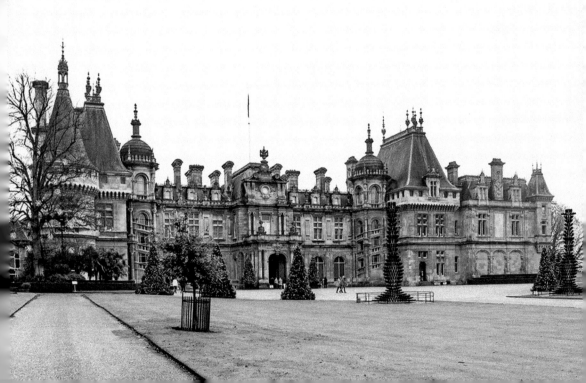

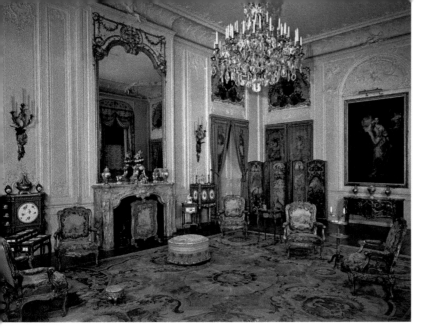

The opulence and money lavished on Waddesdon Manor speaks volumes about
the wealth of the Rothchilds as it was only to be used as a setting for the families art
collection and as a place to entertain friends at the weekend. The house also contains
extensive gardens and a landscaped park, which were laid out by French landscape
architect Ellie Laine, who had created numerous parks and gardens for Leopold II
of Belgium.

The last member of the Rothschild family to own the house was James de
Rothschild, who died in 1957. He bequeathed the house and its contents to the
National Trust. It is one of the trust's most visited properties attracting over 450,000
visitors a year. One of the contradictions about Waddesdon Manor is that it is one
of England's greatest stately homes, yet little about the house speaks of 'Englishness'.

32. Bletchley Park

Bletchley Park is a modest Victorian mansion situated in the heart of the town of
Bletchley, which is fast becoming a suburb of Milton Keynes new town. A house
has existed on the site for over 300 years when the first structured was built in 1711
by the antiquary Brown Willis. This was purchased in 1793 by Thomas Harrison,
who demolished it. It became known as Bletchley Park after it was acquired by
Samuel Seckham in 1877. The 581-acre estate was subsequently bought in 1883 by
Sir Herbert Leon, who expanded the then existing farmhouse into what was described
at the time as a 'maudlin and monstrous pile combining Victorian Gothic, Tudor
and Dutch Baroque styles'. It seems that the house was not considered anything
special, for in Sir Nicolas Pevsner's *Buckinghamshire (Pevsner Architectural Guides:
Buildings of England)*, published in 1960, it is not mentioned. Indeed the entry for
Bletchley points out that there are no Victorian buildings that need singling out.

However, Bletchley Park's reputation does not rely on its architecture – good or indifferent. Its fame and its place in the nation's history derives from the role it played during the years between 1939 and 1945, for the house is arguably the most important Second World War military location in the whole of Britain.

In 1938 the mansion and much of the site was bought by a builder planning a housing estate, but in May 1938 Admiral Sir Hugh Sinclaire, at the time head of MI6, bought the mansion and 58 acres of land for £6,000, using his own money after the government said they did not have the budget to do so, for use by government code and cypher school.

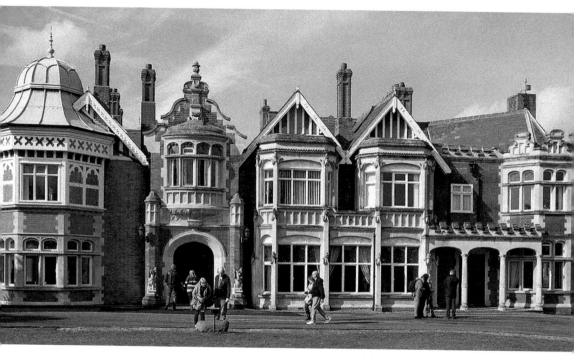

Above: Bletchley Park.

Right: Code-breakers at work during the war.

The house would become Station X, and it was there, with the pre-war help of Polish mathematicians, that the German enigma code was broken and deciphered allowing the Allies to monitor the Nazis military movements and battle plans.

Bletchley's work was essential to defeating the U-boats in the Battle of the Atlantic and other British naval victories. The code-breakers were also instrumental in thwarting the German's North African campaign, which saw the British victory at El Alamein in 1942.

Perhaps Bletchley's most significant contribution to the war effort was the role it played in the D-Day landings in June 1944; the Allies knew the locations of all but two of Germany's fifty-eight Western Front divisions. It is without doubt that the work carried out at Station X shortened the war by two years, helped defeat the Nazis and consequently saved thousands of soldiers and civilians lives.

The one name most connected with Bletchley is Alan Turing, Cambridge, mathematical genius and code-breaker who played a pivotal role in the defeat of the Germans. His work at Bletchley and later at the National Physical Laboratory resulted in the Turing Machine, which is considered to be the forerunner of the modern computer.

Today Bletchley Park has become a museum and is open to the public. It contains numerous exhibits and the full story of how this unassuming, modest Buckinghamshire mansion played such a deciding role in the outcome of the Second World War.

33. Stowe

If I was forced to choose just two of the fifty Buckinghamshire gems contained in this book, one would be West Wycombe and the other, undoubtedly, would be Stowe House and its associated landscaped gardens. Due to its beauty, history and magnificent buildings it is considered the most important place in the county. There is not enough word space here to go fully into Stowe's fascinating history, so it will be up to the reader to make the effort to visit this truly remarkable site. It is well worth it.

The name Stowe is of Anglo-Saxon origin and probably means 'an ancient holy place'. Following the Norman Conquest, William I gave it to his half-brother Odo, Bishop of Bayeux. The parish church of the Assumption of the Blessed Virgin was established in the twelfth century, with later architectural additions. Although today Stowe is mainly identified with the house and the gardens, it is named after the small village of the same name. In 1712 it consisted of thirty-two houses and 180 residents. As the original estate expanded, the village was absorbed until the only remaining feature was Stowe church.

The house was established in the sixteenth century by a prosperous yeoman sheep farmer named Peter Temple, a native of Witney in Oxfordshire. Temple saw the land at Stowe while taking his flock to market at nearby Buckingham.

In 1571, Temple leased the land at Stowe. At that time there was an existing medieval house on the site, but that would soon become inadequate, for the Temples were inspired to social success. John Temple, Peter's son, purchased the land outright in 1589. It was John's son, Thomas, who began the long climb up the social ladder by purchasing a

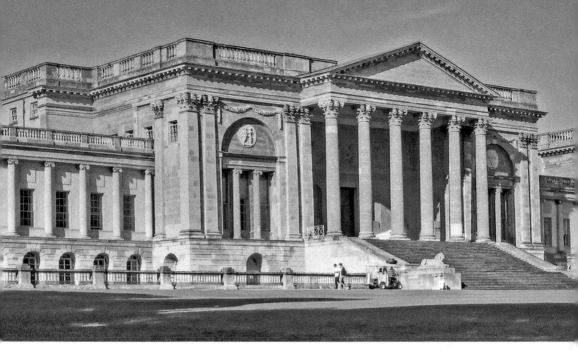

The magnificent neoclassical façade of Stowe House.

baronetcy from King James I in 1611, but it was left to Sir Thomas's grandson, Richard Temple, to begin the building of what would become Stowe House in 1680.

Richard Temple was succeeded by his son, also named Richard (later Viscount Cobham), and it was he who began the design of the landscape gardens for which Stowe is famous. Cobham also lavished money upon the house to such an extent that it became known as 'Stowe Palace'.

Viscount Cobham's nephew, Richard Temple-Grenville, later named Earl Temple, inherited the estate in 1749. Temple is responsible for the magnificent house we see today. He added the colonnaded north front, and initially called in Robert Adam to plan the south front, but was unsatisfied with the result of the design and turned to his cousin, Thomas Pitt, to finish it in a manner more to his taste. The result is perhaps the best example of neoclassical-style architecture still in existence in Britain.

The stunning neoclassical interior was designed over a period of decades by a number of architects employed by Temple and his nephew, the Marquess of Buckingham, such as Blondel, Valdre, and Borra. The interior we see today is largely from this period.

The following years saw the fortunes of the house and its owners sail into troubled waters. Stowe had been inherited by the 1st Marquis of Buckingham. His descendants put little money into the house, probably because the money had all gone, and the family fortunes underwent a sudden dip in the early years of Victoria's reign. In 1848 things had become so bad that a major auction was held of the furnishings of Stowe House. £75,000 was raised, not an inconsiderable sum.

Unfortunately, the 2nd Duke had debts of over £1.5 million, and he had no option but to close Stowe House. Eventually the house was put on the market and purchased in 1922 by a property developer named Harry Shaw. Shaw wanted to preserve Stowe for the nation, but he was unable to raise the necessary funds and was forced to sell it on. Incredibly, there were plans at the time to demolish the house. Happily salvation came.

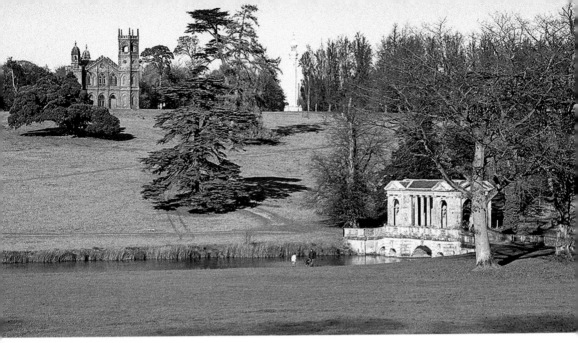

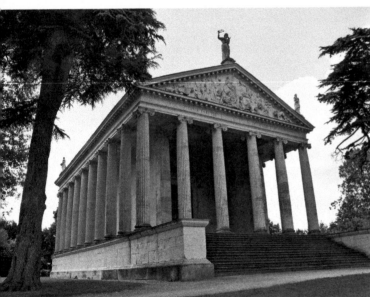

Above: Three of the many classic and Gothic follies that dot the grounds of Stowe House.

Left: Ancient Greece comes to rural Bucks: the incredible full-sized Greek temple in the grounds of Stowe House.

In 1922 the house was purchased to create a new public school. Stowe School opened its doors in 1923, and still occupies the premises today, though the house itself is owned by the Stowe House Preservation Trust. Former 'Old Stoics', as boys of Stowe are called, include actor David Niven, Lord Sainsbury and Virgin boss Richard Branson.

The other chief attraction at Stowe is, of course, the landscaped gardens. Their scale and beauty has attracted visitors for over 300 years. It is a journey back to the world of the eighteenth-century romanticism. Stunning vistas, winding paths, lakeside walks and over forty temples and monuments are set against a backdrop of valleys, hills and trails that cover an area of over 250 acres. It is one of the finest of Georgian landscape gardens not only in Buckinghamshire, but also Britain.

Town Gems

34. Amersham

Amersham is really two places. The new town on the hill is a product of Metro land, so beloved of Poet Laureate Sir John Betjeman. With the extension of the metropolitan railway in the early 1900s, Amersham-on-the-Hill expanded to accommodate the growing number of commuters who travelled to London daily. By contrast, the old town a mile south is a different place altogether. The high street is lined with a host of fine buildings dating from the fourteenth to the eighteenth centuries, and its many courtyards and inns remind us when the town was a stopping place on the old coaching route from London to Aylesbury and the north.

In the early sixteenth century, Amersham was a hotbed of Lollardism. The name Lollard was a contemptuous term for a follower of John Wycliffe, a fourteenth-century theologian, reformer and translator of the Bible into English. Wycliffe had many opinions on the way the church should be run but his main objection was that it was forbidden to read or possess the Bible in the English language. If people were found guilty of heresy, which included owning and reading a bible in English, they would be condemned to be burned at the stake. Amersham saw a dozen or more people connected with the Lollard movement executed between 1414 and 1532. In 1414 four men from Amersham and one from Great Missenden were executed for adhering

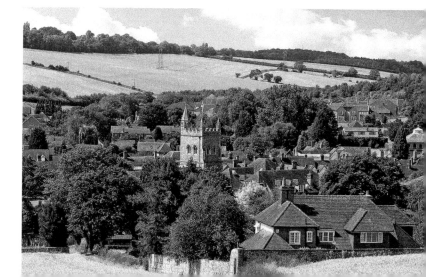

Beautiful Amersham in its Chilterns valley.

Above: The wide Amersham High Street, a reminder of when the town was a route on the old coaching roads from London to the north.

Left: The Martyrs' Memorial overlooking the town. It commemorates the burning of Lollards during the sixteenth century.

to Wycliffe's heretical views. Following the executions of the Amersham men, religious dissent quietened, and many of Wycliffe supporters were forced in to hiding.

Around 1500 there was a Lollard revival in the Chilterns, and while most sympathisers recanted their beliefs, others refused and went to the stake. Among those charged and found guilty was William Tylsworth of Amersham. He refused to recant, and in 1506 was sentenced to be burned to death. The savagery of the time, and the hatred felt towards Dissenters, is reflected in the fact that Tysworth's daughter, Joan, was made to light the fire herself.

In 1521 six men and one woman from Amersham were put on trial in St Mary's Church for Lollardism. They were found guilty and taken from the church to a hill high above the town where each was burned at the stake. The most savage and heartbreaking of the executions was that of John Scrivener: his young children were forced to light their father's fire.

In 1931 a memorial in the shape of a giant granite obelisk was erected on a hill overlooking Amersham to commemorate those who had suffered for their religious beliefs. It stands just 100 yards from where their execution pyres were lit, and looks over a town and countryside mostly unchanged since the sixteenth century. A final view that must have lingered in the eyes and minds of those martyrs back in a savagely, intolerant time.

35. Beaconsfield

Here is a piece of movie trivia: did you know that the opening scene of the very first *Carry On* film made in 1958 was shot in Beaconsfield. As the screen credits of *Carry On Sergeant* fade the exterior of St Mary and All Saints Church comes in to view. It is no surprise as, from 1920 until 1971, the town was the home of British Lion film studios, and many classic British movies were produced there.

A glitzy film studio may seem an incongruous addition to the quaint half-timbered cottages of the town, but Beaconsfield provided the perfect backdrop as the setting of a quirky post-war British community and many of the town's streets and house were used as movie locations.

Beaconsfield – the clearing in the Beech trees – however, is really two places. Like nearby Amersham, the new town to the north grew up around the railway line, which arrived in 1906, and brought with it its own brand of Betjeman Metro land. With London within easy reach and beautiful Chilterns countryside on its doorstep the town quickly drew those tired of the noise and grime of the capital to build their own grand mansions in the growing surrounding suburbia. In 2008, Beaconsfield was named 'Britain's richest town' with Burkes Road being the second most expensive road in the country outside London.

For many years both new and old Beaconsfield were separated by open countryside. Today, development has joined the two, but not in an inharmonious way. The old town was first recorded in 1185 where it is spelt Bekenesfeld. An annual fair was established in the late thirteenth century for the trading of goods and livestock. Today the event has become a modern funfair.

Beckonscot, the world's oldest model village.

Old Beaconsfield remains an attractive location containing a number of fine Stuart and Georgian buildings and pubs. The wide high street reminds us that the town was an important staging point on the coach route between London and Oxford.

Perhaps Beaconsfield's most famous and certainly most visited attraction is to be found in an ordinary suburban street in the new town. Bekonscot is the oldest original model village in the world. It was first created by a local resident Roland Callingham (1881–1961) in the 1920s as a miniature empire to his large back garden, drawing in help from his staff. Together they developed the model landscape portraying rural England at the time. Callingham named the village 'Bekonscot' after Beaconsfield and Ascot, where he previously lived. It was originally developed as a plaything to entertain Callingham and his guests. It was only after 1930 that its existence became widely known, catching the imagination of the press and public alike. Today it is estimated that the village has been visited by more than 14 million people.

36. Aylesbury

The inclusion of Aylesbury as a Buckinghamshire gem might raise a few eyebrows, especially those who only see the town as they drive through on the A41 past the high-rise glass and concrete of the county hall, or the soulless car parks or indeed the great edifice of the Friars Shopping Centre. Yet, if one searches there is another Aylesbury to discover, one that hides away behind the hustle and bustle of the modern-day town. It is Old Aylesbury and it is a delight.

Stately Georgian houses lead to Aylesbury's parish church on a crisp, cold Sunday morning.

Aylesbury took over as the county town of Buckinghamshire in 1725, and since that time has grown in size and importance. The town name is Old English in origin, and was first recorded as Æglesburgh, meaning the 'Fort of Ægel'. However, the town's history goes back before the arrival of the Anglo-Saxons. Evidence of an Iron Age hill fort dating from the fourth century has been discovered. Aylesbury was one of the strongholds of the ancient Britons, probably the Catuvellauni tribe. In the year 571 it was later taken by Cutwulph, brother of Ceawlin, King of Wessex. It had a fortress or castle of some strategic significance, which the early English recognised by retaining the word burgh or bury.

Aylesbury became a major market town in Anglo-Saxon England, and was also the burial place of St Osgyth or Osyth whose shrine attracted pilgrims. She was born only a few miles from Aylesbury in the village of Quarrenden (the village has now vanished, but the scant remains of its church survive). Following her death in AD 700, her father, Frithwald, and mother, Wilburga, took her to Aylesbury to be buried in St Mary's Church. However, following a papal decree in 1500, the bones were removed from the church and buried in secret.

To get the feel and atmosphere of old Aylesbury I recommend the visitor plan their exploration on a sunny Sunday morning. The quietness of the early hour only adds to the enjoyment.

The most satisfying area of the town is around St Mary's Church, which is surrounded by a conservation area. Here many surviving Georgian buildings give the locale a refined character. The Church of St Mary may date back to Saxon times, and it is probable that a twelfth-century place of worship stood on the site. The church we see today is a large cruciform building from the thirteenth and early fourteenth century. It was drastically restored by Sir George Gilbert Scott between 1850 and 1869 and now presents a mostly Victorian appearance.

Sir Nicholas Pevsner thought Church Street the best thoroughfare in Aylesbury. It is lined with eighteenth-century houses and like the surrounding alleyways and squares Ouse's Georgian charm and respectability. A short stroll from Church Street stands the Kings Head Hotel. It dates back to the mid-fifteenth century, and it was here that the doomed Henry VI (who was killed in the tower of London in May 1471 during the Wars of the Roses) and Queen Margaret spent part of their honeymoon. A stained-glass window, which had previously come from the Nearby Greyfriars Monastery (now gone), still exists in the inn showing the king and queen's coat of arms.

Another of the town's most famous buildings is Aylesbury crown court in Market Square. It has been home to judicial proceedings for the county of Buckinghamshire for close to 300 years. The building was constructed on the site of a privately owned house, which was rented out for use as a county gaol. Construction of the new County Hall, as it was to be known, which was to house a new gaol and courtrooms began in 1722 but was not completed until 1740 due to lack of funds. A balcony once wrapped around a central window on the first floor, which was used for public hangings. Crowds would gather in their thousands to witness the macabre spectacle. The last public hanging to take place in Aylesbury was in March 1845 before a crowd of some several thousand people. Other famous cases heard at the court was the trial of the Great Train Robbery in 1964 and that of Rolling Stone Keith Richards in 1967.

Also in Market Square is a monument to Aylesbury's most famous son, Sir John Hampden. He was a Member of Parliament for Buckinghamshire, and it was his refusal to pay the ship tax that ignited the spark that would lead to the English Civil War (*see* Great Kimble). Hampden would die at the Battle of Chalgrove Field in 1643.

The churchyard is circled by quiet alleyways and delightful houses.

Sunday morning is the best time to explore old Aylesbury.

37. Buckingham

Buckingham was established as the county town of Buckinghamshire in the tenth century when Edward the Elder used it as a stronghold in his fight against the Danes in 918. Throughout the ninth century England was continuously raided by the Danes, and one by one the English Kingdoms fell under the yolk of Viking power. A treaty outlined the boundaries of the territory, which came to be known as the Danelaw, and allowed for Danish self-rule in the region. The area was roughly to the north of a line drawn between London and Chester.

Gradually the English began to take back those parts of eastern England occupied by the Danes. The shire or territory of Buckingham was created as a bulwark against further Viking attacks. In 914 King Edward and a Saxon army encamped at Buckingham for four weeks to oppose continued threats from the Vikings. The Saxon fortification probably stood on Castle Hill, on the site now occupied by the parish church of St Peter and St Paul.

Although Buckingham is the first settlement referred to in the Buckinghamshire section of the Domesday Book and would remain the county town, it remained a small quiet ancient place. In 1725 Aylesbury took over the mantle of shire capital and Buckingham continued on in its own sleepy fashion.

On 15 March the town suffered from a significant fire that raged through the centre with the result that many of the main streets were destroyed including Castle Street, Castle Hill and the north side of Market Hill. The result was 138 dwellings being consumed in the fire. Ironically the fine collection of Georgian buildings the visitor sees today is as a direct result of the fire. They include the Buckingham Old Gaol museum, which was built in 1748. It was one of the first purposely constructed gaols in the country. Local landowner Brown Willis wanted to retain the summer assizes at Buckingham, together with the trade and commerce the courts brought to

Buckingham
Old Gaol
at night.

the town. It was built in a mock-medieval style, probably to lend the building an air of antique respectability and ancient authority.

Today, the Old Gaol houses a museum of local life, while the old gaolers quarters houses the Buckingham tourist information centre.

Near to the Old Gaol is one building that escaped the fire of 1725: the Buckingham Chantry Chapel. It was was built in the twelfth century, but is now operated as a second-hand book shop by the National Trust. Although restored in 1875 by Scott, it still retains its beautifully carved Norman doorway.

Buckingham's old Town Hall is an imposing Georgian building topped by a gilded swan, the symbol of Buckinghamshire. The town hall, like the Old Gaol, was built in an attempt to win back the Assizes from Aylesbury. Rising above the marketplace is Castle Hill, the site of a medieval castle built by the Giffard family after the Norman Conquest. It was rarely occupied, and it soon fell in to disuse. The hill is now topped by eighteenth-century parish church, built here after an older medieval church burned down.

The town's parish church, St Peter and St Paul, was built in 1776 following the destruction of its medieval predecessor. The eighteenth-century building would in time be restored by George Gilbert Scott and following alterations to the interior, chancel and porch, it become a mainly Victorian Gothic Revival design.

38. Marlow

Marlow is sometimes referred to as the happiest town in Buckinghamshire. It is certainly one of the prettiest places in the county, lying as it does on the banks of the River Thames some 33 miles west of London. However, despite its charming location, eleventh-century Marlow was 'Mere lafan', meaning 'land left after the draining of a pond'.

It was a Saxon marketplace that developed from a small community into a flourishing town, taking advantage of its situation on the river. It was once ringed by mainly monastic buildings between the eleventh and sixteenth centuries. Some of these old buildings, although incorporated into Marlow's eighteenth-century houses, still remain. The Old Deanery and Parsonage in St Peter's Street form part of what was once the finest fourteenth-century house in Buckinghamshire.

It was during the Georgian period (1714–1837) that the town gained in prominence as a fashionable place to settle. It was in Marlow that Mary Shelly wrote part of her celebrated novel *Frankenstein*. Several fine Georgian buildings remain in the High Street and West Street including Marlow Place, a handsome red-brick house built in the baroque style for George II when he was Prince of Wales. Built in 1720, it later formed part of the Royal Military College before it moved to Sandhurst.

There has been a church in Marlow from as early as 1070; however, the present Church of All Saints is a Victorian creation, built after the spire of the old church collapsed in 1831. The old building was demolished and a new church constructed and topped by a graceful spire soaring 170 feet above the town.

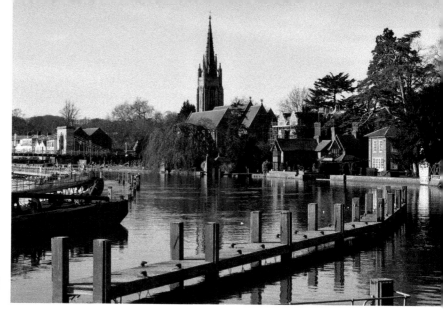

Majestic Marlow on the banks of the Thames.

All Saints Church, together with the towns other outstanding structure, Marlow Bridge, form a memorable vista and identity to the town. There has been a bridge on the site since the reign of Edward II which was recorded in 1530 to have been constructed of timber. In 1642 it was partly destroyed in the Civil War when it was assaulted by Parliamentarian troops. In 1789 a new timber bridge was built by public subscription. The current suspension bridge was designed by William Tierney Clarke and was built between 1829 and 1832, replacing a wooden bridge further downstream that collapsed in 1828. The bridge over the River Danube in Budapest, Hungary, was also designed by William Clark and is a larger-scale version of Marlow Bridge.

Perhaps it is Marlow's literary associations that will appeal to the book lover. In 1817 Percy Bysshe Shelley and his wife, Mary, returned from Italy to live at a house on West Street. It was during the Shelley's stay that Percy finished *Revolt to Islam* and Mary finished her celebrated horror novel *Frankenstein*. In 1918 poet T. S. Eliot made West Street his home, living at the Old Post Office House (No. 31) from 1918 to 1919. The author of *Three Men in a Boat*, Jerome K. Jerome, was also a Marlow resident.

39. Olney

Olney, in the north of Buckinghamshire, is one of the most attractive small towns in the county. It sits on the banks of the River Great Ouse, and is only 2 miles from the county boundary with Northamptonshire. It was first mentioned as 'Ollanege' ('Ollas Island') in 932. Following the Norman Conquest it became the lordship of Geoffrey of Coutance. Coming from a prominent family in Normandy, he became a close friend of William the Conqueror and joined the invasion of England.

It is famous for three things: lace making, hymn writing and as the birthplace of the famous pancake race. Since 1445, a pancake race has been run in the town on Shrove Tuesday, the day before the beginning of Lent. No one is quite certain how

the world-famous race originated. One story tells of a harassed housewife, hearing the shriving bell, dashing to the church still clutching her frying pan containing a pancake. Another says that the gift of pancakes may have been a bribe to the ringer, or sexton, so that he might ring the bell sooner; for ringing the bell signalled the beginning of the day's holiday and enjoyment, no less than to summon the people to the service at which they would be shriven of their sins before the long Lenten feast.

Tradition declares that on the day of the race the whole town was given over to a festival of celebration, pranks and pastimes. It is not known where the original start line was but today the race starts in the marketplace and finishes at the church door, a distance of over 400 yards. Its popularity continued through the centuries, and while many other local customs died, and although the race itself may have lapsed many times, such periods never caused the race to be entirely forgotten by townsfolk. It is even known to have taken place during the Wars of the Roses (1445 to 1487). The traditional prize is a kiss from the verger. In modern times, Olney competes with the town of Liberal, Kansas, in the United States for the fastest time in either town to win the 'International Pancake Race'.

Olney is also known for its eighteenth-century connection with William Cowper and John Newton. They collaborated on what became known as the Olney Hymns. Cowper was born in 1731, and was one of the most popular poets and hymnodists of his time. He wrote of the everyday life and scenes of the English countryside, and is considered one of the forerunners of Romantic poetry. His religious sentiment and association with John Newton (who wrote the hymn 'Amazing Grace') led to much of the poetry for which he is best remembered, for his poem 'Light Shining out of Darkness', which gave English the phrase 'God moves in a mysterious way/ His wonders to perform'. The Cowper and Newton Museum in Olney is dedicated to them. The museum was adapted from Cowper's former home.

The good ladies of Olney running through the town during the celebrated pancake race.

40. Chesham

Chesham, some 12 miles north-east of Wycombe, grew up around the twelfth-century Church of St Mary, which is believed to have been built on a prehistoric holy site. The name of the town is thought to derive from the Old English 'Caestaelesham', meaning 'the river meadow at the pile of stones'. There is evidence that the area was settled as early as the late Mesolithic period (around 5000 BC).

Today the town is a mixture of old and new. British writer, presenter and wit Stephen Fry spent part of his early childhood in Chesham attending the prep school. Lewis Carrol's celebrated *Alice in Wonderland* includes the character the Mad Hatter', which was said to have been based on Chesham resident Roger Crab. He stood over six feet seven inches tall, was a religious fanatic and from 1642 to 1649 served in the Parliamentarian army during the English Civil War. It is said he was sentenced to death by Cromwell for a breach of discipline. The sentence was never carried out, but while in Colchester prison he received a blow on the head, and thereafter his behaviour became somewhat strange. He led a life of celibacy, and propounded the theory that it was sinful to eat flesh or fish or drink alcohol. He dressed in a sackcloth, existed on three farthings a week and lived on a diet of dock leaves and grass. During his life he was imprisoned three times for witchcraft and was often put in the pillory or stocks.

Despite his odd behaviour he returned to Chesham and opened a hat shop. So successful was his enterprise that he became one of the town's richest men. In 1651 he sold his business, gave all his money to the poor and took to the life of a hermit,

A quiet corner of Chesham old town.

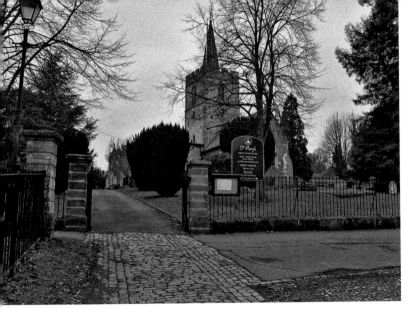

living in a hut in Ickenham near Uxbridge. He died aged fifty-nine in 1680, forgotten
and unmoured. In 1996 builders in Chesham unearthed part of a fifteenth-century
building in the high street, which is thought to be the site Crab's hat shop.

41. Eton

In 1974 Eton was transferred to the ceremonial county of Berkshire, but remained
within the historic boundaries of Buckinghamshire, lying on the opposite bank of the
River Thames, which marks the county boundary. Despite the guidebooks, which
claim the town for Berkshire, it will always be a part of Bucks.

The name 'Eton' derives from the Old English 'Ea tun', literary meaning 'river
town'. The High Street is a pleasant, quiet thoroughfare lined with antique shops
and art galleries. The finely preserved shopfronts include a half-timbered building
believed to date from 1420. Yet it is the college and its associated chapel which
dominates the town. Eton College occupies the whole of Eton north of Barnes Pool
Bridge and was founded by Henry VI in 1440. It is second only to Winchester as the
oldest public school in England. The college chapel made the village a pilgrimage
point, and inns were set up along the High Street. Henry VI gave the college the right
to hold fairs on its grounds.

Eton College was established as a charity school to provide free education to seventy
poor boys, who would then go on to Kings College, Cambridge. The school has been
described as the most famous public school in the world, and is often referred to as 'the
chief nursery for England's statesmen'. The college has educated generations of British
and foreign aristocracy, and for the first time members of the British royal family such
as Prince William and Prince Harry. Eton has a long list of distinguished former pupils
and has produced nineteen British prime ministers including Sir Robert Walpole,
William Pitt the Elder, Arthur Wellesley (the Duke of Wellington), Gladstone, Harold

Macmillan and David Cameron. Indeed Eton, and Windsor, just a stone's throw across the footbridge over the Thames, display all one would need to understand the makings of the British establishment. There is the pomp and ceremony of the changing of the guards at the Queen's favourite royal residence, Windsor Castle, while across the river there is the site of schoolboys destined to become politicians, judges and military leaders dressed in formal tailcoats wandering the streets of tiny Eton.

Above: Eton College and the magnificent fifteenth-century chapel.

Below: The High Street, Eton.

Miscellaneous Gems

42. Bridego Bridge (Site of the Great Train Robbery), Cheddington

On the night of 7 August 1963, a mail train left Glasgow at 6.50 p.m. en route to Euston station in London carrying £2.6 million (worth £46 million today) in bank notes that were to be destroyed. It was due to arrive in London at 3.59 a.m., and its journey south went without incident until forty minutes before arriving at its destination a red signal halted the train at Sears Crossing near the village of Cheddington in Buckinghamshire.

Several masked men entered the cab and coshed the driver over the head, rendering him unconscious. The engine and the first two coaches of the train were uncoupled and driven half a mile further up the track to Bridego Bridge where fifteen robbers smashed there way into the carriages containing the money and proceeded to unload 120 sackfuls of loot into three waiting vehicles, which were waiting in the deserted lane below the bridge. The robbery had taken just under thirty minutes, and soon the men and the millions had sped off through the Buckinghamshire night to their planned hideout 27 miles from the crime scene at Letherslade Farm between Brill and Long Crendon.

The leader of the gang, Bruce Reynolds, escaped abroad, as did Buster Edwards, the robber who was said to have coshed the train driver. The rest of the gang were eventually captured, and at Aylesbury crown court on 15 April 1964, after a trial lasting fifty-one days, they were sentenced to terms ranging from three to thirty years imprisonment.

It may seem odd to include the scene of a crime as a gem of Buckinghamshire. It is not my intention to glorify the perpetrators or find lame reasons or excuses for their motives. No crime is victimless. Yet, socially and historically, the robbery seems to come from another age, a time of a rainy, misty, lamp-lit Britain, caricatured, roguish criminals, cheery police officers who patrolled their remote country beats on bicycles, and a naivety that allowed the Royal Mail to transport millions of pounds across Britain by train without the least bit of thought for security or protection.

Above: The morning after the Great Train Robbery in 1963.

Right: The same scene today.

Nonetheless, for the crime buff, a visit to Bridego Bridge is well worth the journey. The scene is little changed from that momentous night over fifty years ago. Apart from the upgrading of the railway infrastructure on the main London to Glasgow line, the bridge, the lane and the surrounding countryside are as they were. It is easy to stand here on a warm August night and relive the whole dastardly deed.

43. The Edward V Cottage, Stony Stratford

In the introduction to *50 Gems of Buckinghamshire*, I mentioned that Anglophile American author Bill Bryson once observed that it is impossible to walk more than a mile in Britain without coming across something worth losing time to explore or wonder at. How right he is. The only problem that the natives of ancient towns or historic locations have is that we pass by these gems of British history without ever taking any notice or realising their importance and what part they have played in the nation's history. One such location still stands, as anonymous as one can imagine, in the high street of one of Buckinghamshire's most celebrated towns – Stony Stratford. First let me briefly set the scene.

During the mid to late fifteenth century, from 1455 to 1485, England was torn apart by an internecine conflict between the royal houses of York and Lancaster; two opposing families fighting each other for the crown. During the Wars of the Roses many battles were fought, and the fortunes of both houses ebbed and flowed.

However, following the major battles of Towton (1461) and Barnet, and the decisive Battle of Tewkesbury in 1471, the Yorkists finally triumphed and Edward IV was crowned as king. It would seem that the victory of the house of York would have put an end to all the bloodletting, but worse was to come.

Edward had two sons, twelve-year-old Edward, his heir, and Richard, aged nine. In 1483 the king died suddenly and his son was proclaimed Edward V. Edward's uncle, his father's brother Richard, Duke of Gloucester, was named protector. A kindly relative to look after the future king? Not at all, for Richard also had his eyes on the throne.

Shakespeare depicts the Duke of Gloucester as a scheming, murderous tyrant determined to become king at whatever cost, yet his young nephew was the legal heir, a twelve year old with, who knows, decades of kingship ahead of him?

It was at Ludlow on 14 April 1483 that the twelve-year-old prince received news of his father's sudden death. Both the new king and his party, which included his uncle on his mother's side, Earl Rivers, and his half-brother, Richard Grey, set out to London; their journey would take them through Stony Stratford. It was in the Buckinghamshire town on 29 April that the boy king and his entourage were intercepted by the forces of Richard of Gloucester. Rivers and Grey were arrested and later executed. Edward was put in to the custody of his uncle and taken to London to join his younger brother, Richard, in the tower; both would never emerge again.

The scheming Gloucester had succeeded and was crowned Richard III on 6 July 1485. The jury is still undecided as to whether or not he had his nephews blood on his hands. Richard would die fighting two years later at Bosworth, the last English king to die in battle, where he was defeated by Henry VII, the first of the Tudor dynasty.

History, whether retold in books, films, or on the stage can go only so far in reaching out to us from the past and taking us back down the centuries. Existing historical locations and scenes, however, have the power to put us right on the spot where the action took place. Take a walk along the High Street of Stony Stratford and one will come to a seemingly ordinary medieval cottage painted in a faded orangey ochre. This was once the Rose & Crown Inn, and it was here on the night

Above: The cottage in Stony Stratford where Richard of Gloucester seized Edward V.

Right: Richard III. Did he really have his nephews murdered?

of 29 April 1483, that Edward V stayed while breaking his journey to his coronation in London. The following morning Richard of Gloucester arrived to take control of the uncrowned king and remove the last obstacle to the throne.

It is indeed a special location, and it is hard to imagine, in the hustle and bustle of a noisy Stony Stratford day that 500 years ago on this high street and within this humble cottage one of the pivotal events in English history took place.

44. Black Park

Travellers passing through Black Park near Slough could well be forgiven for thinking they were in the depths of Transylvania and that Count Dracula or Frankenstein's monster could at any moment leap from the shadows. In fact they wouldn't be far wrong, as the park have been used on many occasions as a location for the popular Hammer horror films of the 1960s and 1970s, and also a number of the evergreen Carry On comedies as well as the Harry Potter series.

The park is adjacent to Pinewood Film Studios and has been featured in such movies as *The Curse of Frankenstein*, *The Brides of Dracula* and the *Curse of the Werewolf*. It was no doubt cheaper to film in the park rather than haul a production crew to deepest Eastern Europe.

The park has an area of 250 hectares (618 acres), of which a small area of 15.3 hectares has been designated a biological site of special scientific interest and a larger area of 66 hectares as a local nature reserve. It is popular with families, and there are over 10 miles of well-surfaced trackways suitable for buggies and wheelchairs.

The heathland that was to become Black Park was situated alongside the ancient Langley Park, both of which were bought in 1738 by politician and Lord Lieutenant of Buckinghamshire and Oxfordshire Charles Spencer (1706–58), 3rd Duke of Marlborough. The duke went on to enlarge his newly acquired ancient parkland by planting hundreds of fir trees on the site, which became the Pine Walk, soon after his purchase. Within the vast parkland, Spencer commissioned Thomas Greening (1730–1809), head gardener to George II at Windsor Castle, to design and create a lake as a centrepiece for his new found park. The lake was constructed in 1741 by decommissioned soldiers from the War of Jenkins' Ear (1739–48), one of the many wars between Britain and Spain.

Black Park near Slough, the location for many Hammer horror movies.

Situated to the north of the newly formed Black Park is a Victorian manor house known as Heatherden Hall. In 1914 the hall was bought by Canadian financier Grant Morden (1880–1934), who spent thousands of pounds modernising the house, which he eventually turned into a private country retreat for politicians, diplomats, and businessmen. It was at Heatherden Hall in November 1921 that the agreement to form the Irish Free State was signed.

Grant Morden died penniless in 1934, and in order for his estate to pay the obligatory death duties, Heatherden Hall was sold off at auction. It was purchased by Henry Boot, son of a prominent construction and property tycoon of the day. Boot spent twelve months turning the once beautiful baroque house into an office block complex for a movie studio, which he ended up selling to British industrialist and film producer Joseph Arthur Rank (1888–1972). Today Heatherden Hall is situated in the grounds of the world-famous Pinewood Studios, so named because of the fir trees planted by Charles Spencer in 1738.

During the First and Second World Wars, the park saw service for the Empire with troops from the Canadian Forestry Regiment helping to farm the park and harvest the wood for use in the trenches of France or building airstrips in France for the Royal Flying Corp. Today the lines of trees they planted can still be seen. It was also used throughout the Second World War as a for store military supplies, which were hidden among the trees from enemy surveillance.

45. Water Stratford Church

The phenomena of fanatical religious cults presided over by deluded self-proclaimed new messiahs, and followed, unblinkingly, by devoted converts seeking alternative spiritual enlightenment would seem to be a product of the 1960s counterculture. Yet such lunacy is nothing new.

The village of Water Stratford, 2 miles west of Buckingham, would seem to be the last place one would think of escaping to in the advent of a prophetic, fiery Armageddon. Yet, this sleepy Bucks backwater was, in 1690, besieged by a deluge of fanatical disciples convinced that it was the only place on Earth that would be spared the ending of the world.

In 1674 John Mason became parish priest of St Giles' Church at Water Stratford. He was a Puritan and was much admired by his fellow clergy. He was a man of gentle disposition and moderate views when he first took up his post. However, he turned to Calvinism. One of its beliefs was that salvation is preordained and that God has chosen those who are to be saved regardless of how devout and spotless a life one leads on earth.

Mason, and his wife lived happily at Water Stratford administering spiritual guidance to his flock for some sixteen years, but then one day it all began to go wrong. In 1690 the good priest was hit by three successive personal blows. A scripture chronology he had worked on for years was rejected by the church authorities and he grieved over his wasted time. Secondly, his closest friend died, and this blow was devastatingly followed by the death of his beloved wife.

Overnight, John Mason became a changed man. He began to experience strange dreams, nightmares and delusions, which haunted his waking hours. His preaching began to take on an alarming dimension. On Sunday mornings he would thunder forth from his pulpit that he was the prophet and miracle worker Elijah, and that he could summon up the dead and bring down fire from heaven. He had been sent to Water Stratford to proclaim that the village had been chosen as holy ground where the good and the privileged few could gather to await the day of destruction while all others outside this sacred boundary would be cast into the pit and destroyed by fire and sword.

Not surprisingly, Mason's superiors in the church began to get a little concerned. Not so his parishioners. Hundreds of people from the surrounding area descended on the Buckinghamshire village eager to hear the word of the new messiah. So great was the impassioned multitude that there became no room in the church and the crowds packed into the churchyard to listen to Mason as he addressed the throng from one of the church windows.

Yet things were about to get even more crazy. Thousands of people from miles around who believed him sold their property and moved to Water Stratford in droves. Some brought tents and pitched them on what they believed was the holy ground. They brought their livestock and mountains of food. They played musical instruments, and kept up a continual racket throughout the day and night. There was singing, dancing and the frenzied clapping of hands. It seemed as if Water Stratford had gone nuts.

Eventually the church authorities sent the Revd Maurice, rector of Tyringham and a close friend of Revd Mason, to Water Stratford to report on what was happening. On his arrival he found the village in pandemonium. Throughout the rectory, men, woman and children were running up and down the stairs bellowing, laughing and clapping as if the Day of Judgment was just around the corner.

While Mason's followers danced themselves into euphoria, he lay in a garret at the top of the house dying. He died a month later, prophesising that he would be resurrected in three days. It was thought that his passing would put an end to the madness. However, it was not to be, as three days after the reverend had been laid to rest the multitude still remained in the village, and the din of singing and chanting continued as they waited for Mason to rise from his coffin.

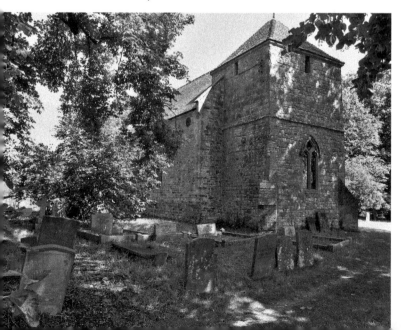

Water Stratford churchyard, the scene of seventeenth-century mayhem.

In desperation Mason's successor, Revd Rushworth, opened up the rector's grave and displayed the corpse to show one and all that their leader was, indeed, stone dead. Incredibly there were some who still believed that Revd Mason would put in an appearance and they hung around the churchyard for up to sixteen years. Eventually they were dispersed by the army.

The church authorities put the rector's weird behaviour down to smoking to much tobacco. It had obviously overheated his brain and so kindled the zeal that brought about his end.

46. Dinton Folly

The traveller passing by the village of Dinton, on the Aylesbury to Thame road, will view what appears to be a ruined medieval castle. In fact it is a castle of sorts, but a sham construction and certainly not from the Middle Ages, for this is Dinton Folly, and despite its ancient-looking stone and crumbling masonry, it dates only from 1769. It was built by the then lord of the manor of Dinton, Sir John Van Hatten, to house his fossil collection and to be viewed as a prospect of romantic pleasure.

The structure was never completed as Sir John ran out of money, yet it is probable that had Van Hatten possessed the required funds to finish the building he would not have done so, for the whole reason of follies is to have no purpose other than being contemplated and admired as a romantic vista. It did became the meeting place for a local Non-conformist congregation, but they had to make do with using tarpaulin as a makeshift roof in bad weather.

Van Hatten came to England in 1688 during the reign of William III, and bought Dinton Hall from the son of Simon Mayne. Maine was MP for Aylesbury and was one of the men who signed the death warrant of Charles I.

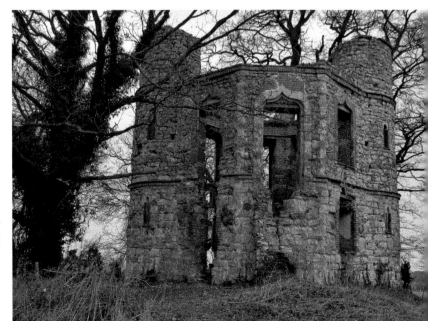

Sir John Vanhattens sham eighteenth-century medieval ruin at Dinton.

Following the Parliamentary victory at the Battle of Naseby in 1645, Simon Mayne entertained Oliver Cromwell at Dinton Hall. It is curious to wonder what conversation passed between the two. Both knew that once the king was defeated he had to be tried, and executed if he was found guilty. The question was who would be given the task of carrying out such a bloody act? Tradition says that John Bigg, a clerk from Dinton, was persuaded to be the monarch's executioner. On a freezing January day in 1649, his axe came slicing down on to the king's neck, omitting from the watching crowd such a moan as had never been heard before.

Following the restoration of Charles II in 1660, Simon Mayne was arrested, tried and sentenced to death. He died in the Tower of London in 1661 before his appeal could be heard. The new king established a commission to find those who had executed his father. Many eyewitnesses were questioned and several possible names put forward, yet no firm evidence was forthcoming as to the axeman's identity.

Back in Dinton, John Bigg lived to the respectable age of sixty-seven, and was buried in the churchyard. Yet, throughout his later years he was said to be full of remorse for his part in the death of an anointed monarch. He lived a solitary existence and became known as the Dinton hermit, living in a cave located somewhere in the village, but it is possible that Simon Maynes son took pity on him and gave him sanctuary and anonymity at Dinton Hall.

His ghost is said to haunt Dinton Folly, although he died some seventy years before it was built. Recent research, however, has tantalisingly hinted at where Bigg's cave could have been. In 2017, builders restoring the ruined folly are said to have discovered the entrance to a tunnel beneath Van Hattens sham castle leading in the direction of Dinton Hall. Could this be John Biggs secret cave? If it is not the spirit of the hermit that haunts the crumbling ruins, it may be phantoms from an even more ancient time as evidence has been discovered that the folly stands on the site of an Anglo-Saxon burial ground.

47. Icknield Way

The Icknield Way is an ancient track said to be the oldest traceable route in Britain. It runs approximately some 360 miles from Norfolk to Wiltshire following, in places, the chalk escarpment that includes the Berkshire Downs and the Chiltern Hills. The name is probably Celto-British in derivation, and may be named after the Iceni tribe who controlled much of what is now Norfolk and Suffolk in the centuries before the Roman invasion of Britain. They may have established the route to permit trade with other parts of the country from their base in East Anglia.

Part of the route crosses the southern half of Buckinghamshire, and in many places consisted of several trackways as it passed along the line of the Chiltern Hills, probably because of the seasonal usage. The upper way is used in winter to avoid the swamps and floods of the plain.

The earliest mentions of the Icknield Way are in Anglo-Saxon charters dating from the year 903 onwards. The oldest surviving copies were made in the twelfth and

The macadamised Icknield Way near Bledlow, the oldest recorded road in Britain.

thirteenth centuries, and one of these refers to the Buckinghamshire town of Princes Risborough. Indeed the track enters Bucks near the village of Bledlow, near Risborough, where it runs under and around Bledlow hill. Other sections of it can be followed at Whiteleaf and on to the village of Little Kimble. Remarkably many of the sections of the Ickneild Way in Bucks have been incorporated into the modern road system. The route continues on across the county towards Marsworth, Ivinghoe Beacon and Edlesborough where it passes out of Buckinghamshire and into Bedfordshire.

The Icknield Way is a marvellous route for walkers and history buffs. To tread along its grassy tracks or to pound down its now tarmaced road is to follow in the footsteps of our ancient ancestors.

48. Coombe Hill

For the lovers of spectacular views, Coombe Hill takes some beating. It rises 852 feet above sea level and is said to be the highest point in the Chilterns, although this is disputed by supporters of Haddington Hill, near the town of Wendover, which they say is at least 24 feet higher. To make things a bit more confusing, there is another Coombe Hill on the flank of Haddington Hill. Whatever the true height of the respective hills, from the top of 'our' Coombe Hill you get extensive

Coombe Hill, said to be the highest point in the Chilterns, looking out over the Vale of Aylesbury.

views over the Aylesbury Vale and on a clear day it is possible to see all the way to the Cotswolds.

Rather mystifying is the name 'Coombe'. It is Brythonic, or British, in origin and means 'hollow', which is a curious description for such a lofty place. One of the oldest features on the hill is the remains of late prehistoric (Bronze Are or Iron Age) cross dyke, which is a visible earthwork. Consisting of a shallow ditch around 8.5 metres across and 0.5 metres deep, it runs from south-west to north-east on the west facing slope about 400 metres south of the summit. It was probably dug to defend a route or to demarcate a territory.

For the lover of wildlife, fauna and flora Coombe Hill is a real treat. It is designated an SSSI (Site of Special Scientific Interest) due to its chalk grassland and acid heathland, which is home to over thirty species of wildflower and twenty-eight species of butterfly. The most prominent plants to be found are rock rose, marjoram, basil and thyme. For the botanist, butterflies such as small heath, meadow brown, ringlet and common blue are found on its slopes.

The 106-acre hill once belonged to the Chequers estate but was handed to the National Trust in 1918 by Lord and Lady Lee of Fareham at the same time as the Chequers House (*see* Chequers) was handed to the country as a country home for the serving prime minister.

On the summit of the hill stands an obelisk dedicated to the men from Buckinghamshire who gave their lives in the Boer War. The monument was erected in 1904 in memory of 148 men from Buckinghamshire who died during the Second Boer War. The monument was almost totally destroyed by lightning in 1938 and was rebuilt in the same year. It was again struck by lightning in the early 1990s and spent several months in repair. It is now equipped with lightning conductors to prevent this from happening again.

During the Second World War, the Boer War Memorial had to be camouflaged to avoid it being used as a sighting landmark by enemy aircraft. To service the site, a brick service road was constructed between the entrance gate and the monument. The brick road still underlies the gravel access track that leads to the summit.

49. Boarstall

Boarstall is a small village in the Vale of Aylesbury, almost on the county boundary with Oxfordshire. To drive through it is a somewhat underwhelming experience. There is no pub, or shop or village green. The Church of St James is a small dull building of 1818, which was over restored in 1884. Then why is it included as a gem of Buckinghamshire? There are three reasons: the village contains Boarstall Tower, a fourteenth-century moated gatehouse and its surrounding gardens. Both are National Trust properties open to the public. There is also the Boarstall duck decoy. At one time a common sight in the English countryside, only four duck decoys now remain. The Boarstall duck decoy is still in working order and is surrounded by 13 acres of woodland.

The decoy was a means to catch large numbers of waterfowl and a decoy or fake duck was used to attract birds onto a small patch of water that was equipped with a long cone-shaped wickerwork tunnel. A 'decoyman' with a trained dog then herded the birds into the tunnel. Once the birds had been trapped in the wickerwork, they could then be caught as required. The birds trapped in a decoy were a source of food and commanded higher prices than shot ducks as the lead shot or pellets did not have to be removed from their bodies. The decoy was built between 1691 and 1697 and still remained in use until after the Second World War. Indeed it is still in use today, although not to provide food, instead trapping birds to be tagged for ornithological study.

The duck decoy at Boarstall.

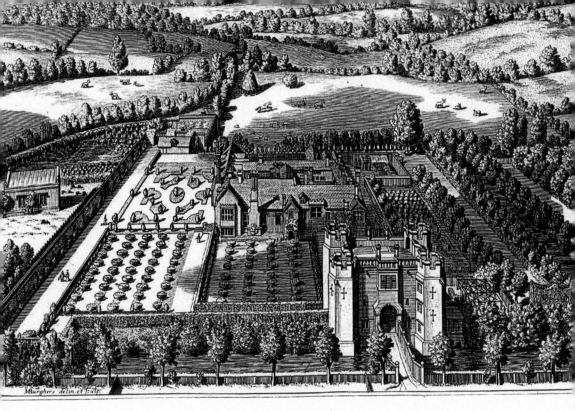

BOARSTALL in 1695.

Above: A print showing the sumptuousness of the extensive Boarstall House.

Below: Boarstall Gatehouse, the last remaining part of Boarstall House.

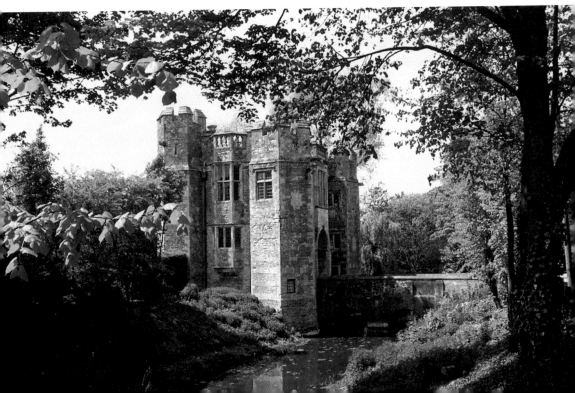

The village was named, so legend says, after King Edward the Confessor granted some land to one of his men in return for slaying a wild boar that had infested the nearby Bernwood Forest. The man built himself a mansion on this land and called it 'Boar-stall', Old English for 'Boar House', in memory of the slain beast. The manor was fortified in 1312 by John de Haudlo with the construction of a defensive gatehouse. The house was demolished in 1778 but the gatehouse – very large and grand for its time – survives today relatively unaltered as Boarstall Tower.

During the English Civil War the tower changed hand on several occasions. It was fortified as a garrison by Charles I, who was in possession of the nearby village of Brill. When Brill fell in 1643, so did the garrison at Boarstall. However, whereas the manor at Brill was destroyed in the fighting, the fortified manor at Boarstall was saved and used as a garrison by Parliamentarian Sir John Hampden in order to attack the city of Oxford 8 miles away. In 1644, having no further use for the manor, Hampden left to go and fight elsewhere. The house was then retaken by the Royalists, whom it is said launched such heavy fire from their cannons against the house that the incumbent Lady Denham was forced to evacuate and steal away in disguise. The Royalists left a small garrison in place to defend the house; however, in May 1645 the house was once again assaulted by the Roundhead forces, this time led by Sir Thomas Fairfax, but he was unsuccessful. The following year Fairfax returned, and the house surrendered to him on 10 June, after a siege of less than eighteen hours.

50. Kop Hill and Whiteleaf Hill

Another location in Bucks that will delight the car enthusiast, lovers of ancient and modern history, and those who just love to take in stunning scenery is just outside the town of Princes Risborough.

Kop Hill is a public road with a gradient of 1 in 6 leading to 1 in 4 at its steepest. In 1910 motorcyclists, and later motorists, decided to test their machines and nerves by attempting to be the fastest to climb the hill's dizzying gradient. The event quickly became a must do in the motor sport calendar, and attracted the greats of the day including legendary Bluebird driver Malcolm Campbell.

As the event progressed over the years so did the speeds reached by the competitors. The fastest recorded assent was an astonishing 81 mph in 1925. Unfortunately, during the same event a spectator was injured by a speeding car and the climb was considered too dangerous and banned by the Royal Auto Club. Happily the hill climb was revived in 1999, and today has become a major event and part of the Risborough Festival.

Those competitors who succeed in reaching the summit of Kop Hill will be well rewarded with stunning Chilterns scenery and reminders of Buckinghamshire's ancient past and sacrifice in the First World War.

On Whiteleaf Hill an oval Neolithic barrow can be found (4th millennium BC), which was first excavated between 1934 and 1939. Archaeological evidence suggests

The lofty summit of Kop Hill.

that the barrow contains a middle aged man between 5 feet 6 inches and 5 feet 9inches in height, with a long and narrow skull. Pottery shards and animal bones were found at the core of the mound and it is thought that these came from ceremonial feasting when the mound was built. The status of the individual and why he was laid to rest on Whiteleaf Hill are unknown, but he must have been a man of significance in local society. Perhaps he was accorded such a last resting place because of its stunning vista over the surrounding Chilterns landscape, for the view from Whiteleaf Hill is spectacular.

This area is an ancient Buckinghamshire landscape. Just to the south of the oval barrow, crossing the path leading to the car park, another earthwork thought to be a late Bronze Age boundary has been discovered by archaeologists. The ancient trackway known as the Icknield Way, which ran from the Wash to Wessex, passed through the parish. Also a section of the extensive earthwork known as Grims Ditch can be found nearby. It is thought to be an Iron Age boundary dyke.

There are further historical curiosities to be discovered on Whiteleaf Hill. Alongside a pathway, which leads from the car park to the summit, there lies – hidden amongst trees and undergrowth – a line of depressions, mounds and hollows which to the untrained eye would appear to be the natural rise and fall of the land. However, that assumption would be incorrect because these contours are man-made, and they look out over a landscape of fields backed by woods that would in time become chillingly familiar to the men who dug them 100 years ago. These are practice trenches excavated by locally garrisoned soldiers who in August 1914 would soon be ordered to France to confront the German war machine, and where many of them would fight and die in the struggle that would come to be known as the Great War.

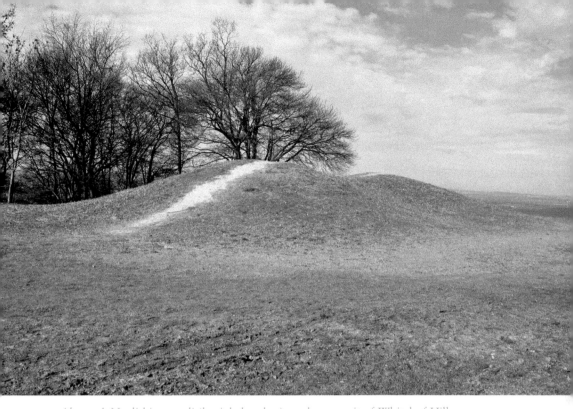

Above: A Neolithic tumuli (burial chamber) on the summit of Whiteleaf Hill.

Below: On nearby Whiteleaf Hill one can still find practice trenches dug by soldiers who would soon have to face the horrors of the Western Front.

About the Author

Eddie Brazil was born in Dublin in 1956 and was later raised in south-east London. He is a writer, photographer and paranormal investigator. He is co-author, with Paul Adams and Peter Underwood, of *The Borley Rectory Companion* and *Shadows in the Nave: A Guide to the Haunted Churches of England*. In 2012, he wrote *Extreme Hauntings, Britain's Most Terrifying Ghosts* with Paul Adams, and in 2013 he published the first ghostly guide to *Haunted High Wycombe*. He has also written on the *Bloody History of Buckinghamshire*. He has recently completed *Haunted Camberwell and Peckham*, which he hopes to publish this year.

He is also a guitarist, and in 1983 wrote the theme music to the British comedy *Expresso Splasho*, which featured Gary Oldman and Daniel Peacock. Eddie lives with his wife and daughter in High Wycombe, Buckinghamshire.